Digital Manipulation Basics

Digital Manipulation Basics

LES MEEHAN

COLLINS & BROWN

First published in Great Britain in 2004 by
Collins & Brown
The Chrysalis Building
Bramley Road
London
W10 6SP

An imprint of **Chrysalis** Books Group

Distributed in the United States and Canada by
Sterling Publishing Co.
387 Park Avenue South, New York, NY
10016, USA

British Library Cataloguing-in-Publication Data:
A catalogue record for this book is available from
the British Library.

ISBN: 1-84340-169-X

Designed by Anna Pow
Edited by Fiona Corbridge
Indexed by Isobel Mclean
Proofread by Mary Lambert

Reproduction by Classic Scan, Singapore
Printed and bound by Kyodo, Singapore

Contents

Introduction

This book is aimed at people with digital cameras who want to begin exploring the wonderful world of digital image manipulation. It has been written as a logical step forward from *Digital Photography Basics*, the first book in the *Digital... Basics* series.

The book assumes no prior knowledge of digital manipulation, so it is suitable for the absolute newcomer, and all the explanations are easy to read and follow. It is divided into three chapters: Correcting Basic Faults, Getting Creative, and Making Pictures Work. The bulk of the manipulation techniques are in the Getting Creative section; the other sections contain crucial information to help you get the most from your digital explorations. Most of the techniques have been completed using Adobe Photoshop Elements software. This is an affordable alternative to the professional version, Adobe Photoshop (used for some of the projects).

So, delve into the techniques with a spirit of adventure; have fun experimenting with the various ideas, and discover your own unique approach.

Family fun
People of all ages can enjoy the fun of digital image-making, so let the whole family join in.

Correcting basic faults

This section of the book examines the faults commonly found on digital images, and explains how to correct them. Pictures may be too dark, too light, not sharp, or have poor colour balance or contrast problems. The use of flash to take family snapshots often results in the dreaded red-eye effect, which makes people look like devils! Taking pictures of buildings, where it is necessary to point the camera slightly upwards, may produce another annoying effect – the building appears narrower at the top than the bottom (a phenomenon called convergence), which makes it look as though it is falling backwards.

These and other common problems are dealt with in the following pages, providing you with a firm foundation to prepare pictures for further creative exploration as you work through the rest of this book.

Old luggage

Just like this stack of old luggage, many digital pictures commonly contain faults and other undesirable details. Image manipulation programs counter these problems to make pictures look their best.

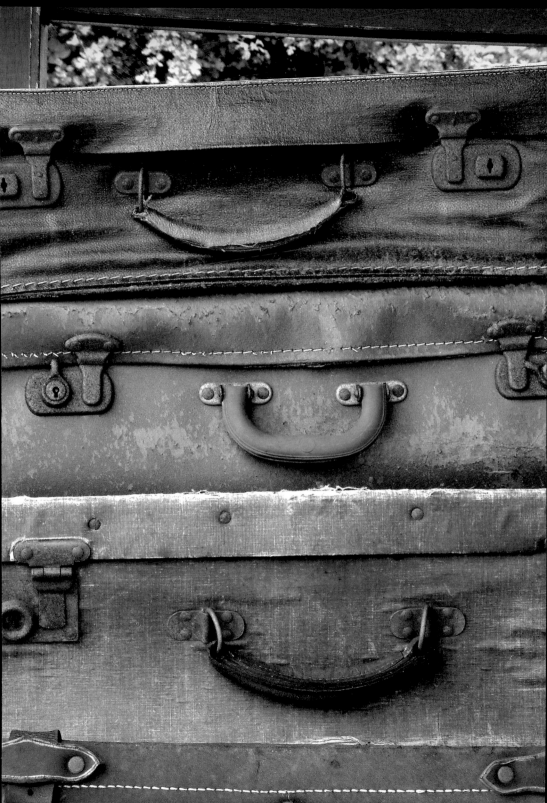

Adjusting the monitor

Before you start manipulating your digital photos, it is important to understand that the colours and tones you see on your computer monitor might not be what you eventually see in your print. A monitor has three basic attributes: brightness, contrast (or gamma) and colour balance, which must be set accurately if your pictures are to be shown correctly on the monitor.

If you are using Adobe Photoshop or Photoshop Elements, there is a calibration utility called Adobe Gamma in the control panel. This utility can be used to create a

Adobe Gamma utility

This is the interface for the Adobe Gamma monitor calibration utility, which is installed as part of Adobe image packages. Set the contrast of the monitor to 100%. Now choose either the Wizard button (bottom right), which will step you through each stage of the calibration, or use this dialog box to make changes.

Adjusting brightness

To calibrate monitor brightness, adjust the brightness control until the row of black and grey patches in the Brightness and Contrast panel almost merge together. Notice how the dialog box has darkened in response to the brightness being reduced.

unique ICC-compliant profile for the monitor. Before using Adobe Gamma, make sure the monitor has been switched on for at least 30 minutes to allow the screen phosphors to stabilize.

To calibrate the monitor effectively, it is necessary to remove any colourful wallpaper or images from the desktop. It is also advisable to make the desktop a neutral grey (use a value of 128), so that when performing the calibration, your eyes are not influenced by the desktop colour. A neutral desktop colour will also help in achieving the correct colour balance.

The lighting and environmental colour in the room can also affect calibration, so endeavour to keep the room conditions the same during calibration and when you are editing photo images.

Adjusting the Gamma

The Gamma controls the colour and mid-tones of the display. Squint your eyes as you look at the screen and move the slider under the sample grey patch until the centre merges visually with the outer edges.

Adjusting colour

For fine control over the colour of the monitor display, adjust the Red, Green and Blue (RGB) individually. The aim is to achieve a neutral grey in the dialog box. The last screenshot shows the result of increasing the red.

Demonstration of an un-calibrated and calibrated monitor

Monitor calibration makes a dramatic difference to how you see and assess the tones and colours of your photos. The same photo, viewed on a uncorrected and corrected monitor, will look totally different. A monitor that has its brightness set too high, and a green colour cast, will produce the result shown in the first image. The second image shows the photo on a corrected monitor.

Cropping to the essentials

Often, photographs turn out to include a wider area around the subject than you intended. There will also be times when something distracting appears at the edge of a photograph, such as a tree branch. The answer to these problems is to crop the image. This much used and powerful creative technique allows you to give more impact to a picture by concentrating attention on the main subject, or improves it by removing unwanted edge details.

Most image manipulation programs provide a Crop tool that allows you to select a rectangular portion of the image, which is then retained; the image area outside the selected region is permanently deleted from the image file.

Cropping should always be carefully considered, because it is quite possible to crop too much from an image. Before committing to a final crop, decide whether the main subject (and the overall composition) would benefit from some space around it. Space can enhance the impact of a picture, giving the main subject room to breathe. A crop that is too tight can leave the main subject looking visually "pressed in" by the sides of the picture.

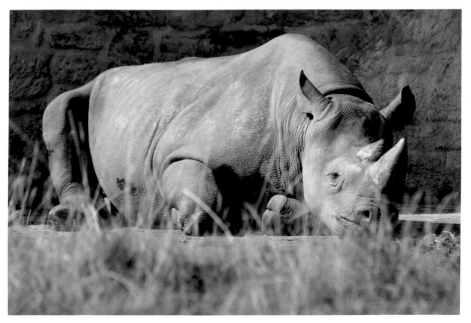

Sleepy rhino: original shot

This image was taken with the zoom lens at maximum focal length – it was impossible to get nearer. Although I quite like the picture, I wanted it to be a more personal, closer view of the head. The answer was to crop later!

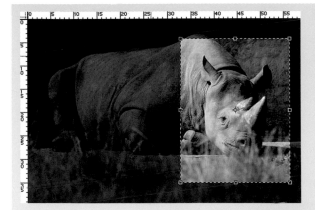

The Crop tool

To use the Crop tool, select it, and then drag a rectangle around the area you wish to retain, as shown in this screen grab. Use the small, square "handles" at the edges and corners to fine-tune the size of the crop area, then double-click inside the cropped region to activate the crop. To cancel the Crop tool without cropping, press the Escape key.

Rhino head

The final image after cropping. Notice I have provided a little room around the animal to suggest its surroundings and "place" the main subject. Of course, I could have cropped even more tightly, but this would have isolated the head too much and removed the single foot that shows the rhino is lying down.

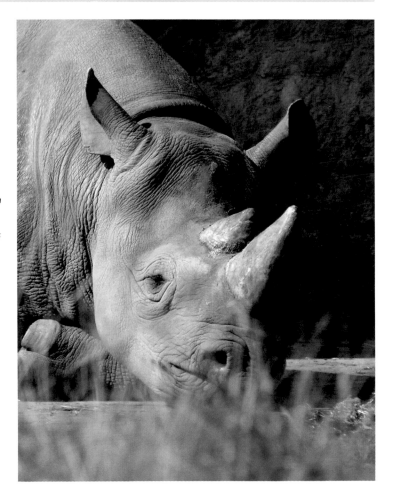

Fixing dark pictures

Many people tend to use their digital cameras set to auto-exposure mode. This often produces incorrectly exposed pictures. Problems occur when the sun is included in the picture, or the subject has a predominance of light tones and colours, such as a bride in a white wedding dress, or a white building. In these conditions, auto-exposure cameras are fooled into underexposing the image, resulting in pictures that are too dark. People who use manual-exposure cameras will also fall into the same trap if they do not understand how the camera's light meter behaves.

Although much can be done to rescue an underexposed picture, you cannot avoid

**Yacht race:
original shot**
*The large white sail in
the centre of the
frame has fooled the
camera's spot meter
into creating a dark,
underexposed picture.*

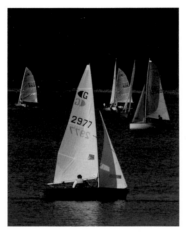

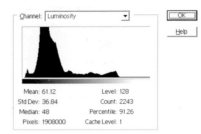

Original histogram
*This histogram of the original image is typical of
an underexposed picture and shows that most
of the tones are too dark (towards the black
end of the scale).*

Auto Levels
*Image manipulation
programs usually have
automatic correction
commands, but they
are not particularly
effective. Here, I
have used the Auto
Levels command in
Photoshop Elements.
It has excessively
lightened the whites
and not much else.*

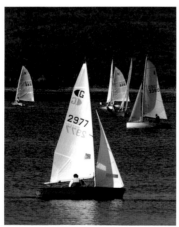

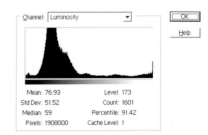

After using Auto Levels
*Compare this histogram of the auto-corrected
image to the original – you will see that the
dark tones have hardly changed.*

the fact that the quality of the image will suffer. Underexposed images are characterized by a loss of detail in the dark tones, whilst light tones appear too dark. The lost detail cannot be replaced and often results in black shadows devoid of any interest.

In most image manipulation programs, the Levels command is used to improve exposure problems. You can try and rescue pictures that are too dark by lightening the tones and colours of the image, moving the triangular Input Level sliders (grey, middle; white, right) to the left. The white slider will lighten mainly the "whites" of the image; the grey slider allows you to lighten the darker parts of the image. Although you can lighten all the tones of the image, the darkest tones may not show any additional detail. In fact, the darkest tones are likely to break up due to excessive manipulation.

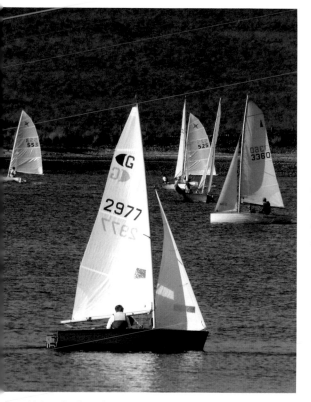

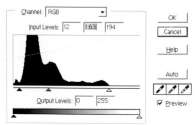

Levels dialog box

This screenshot of the Levels command dialog box shows the settings used to correct the image manually. Note that the white and grey sliders have been dragged to the left, in order to lighten both the white and middle tones of the image.

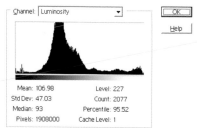

Using the Levels command

The Levels command gives you much greater control over the full range of tones in the image. It has allowed me to correct the white sails as well as the middle tones of the image, producing a much more pleasing result.

Corrected histogram

The final histogram shows how most of the tones have been moved right on the tone scale to become lighter in the picture. Compare this histogram to the Auto Levels version.

Fixing light pictures

Overexposure is the exact opposite of underexposure. Overexposed pictures are too bright, and all the tones and colours look washed out and pale. Overexposure can occur when the camera's light meter is fooled by a subject with large areas of shadow. The other common cause of overexposure is simply operator error when using a camera in manual mode.

As with underexposed pictures (*see pages 15–16*), the Levels command is used to adjust the tones of overexposed images. This time, the triangular Input Level sliders (black, left; grey, middle) are moved to the right to darken the tones of the picture. To darken the lightest tones, it is necessary to move the white triangular slider on the Output Levels scale to the left.

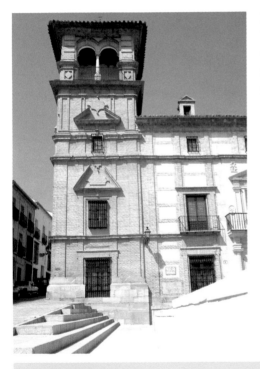

Plaza tower: original shot
The picture (left) is overexposed: notice how everything looks too bright and the colours lack saturation. In particular, the very light wall and steps at the base of the picture lack a sense of solidity.

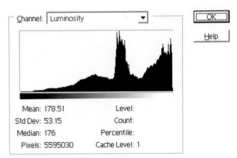

Overexposure histogram
This histogram of the overexposed picture shows that most of the tones depicted on the graph fall on the right, indicating that they are too light. Note also that there are virtually no very dark tones at the left of the graph.

Burnt-out whites

Overexposure often causes the lightest areas of the subject to lose detail and be recorded in the photo as pure white. Since there is no detail, the only "correction" you can try is to darken the pure white very slightly to give a sense of tone. This is achieved by moving the white triangle to the left on the Output Levels scale in the Levels dialog box. This has the effect of making the white areas slightly grey. Don't overdo this correction or the whites will look dull and lifeless.

Overexposed church and clouds

Whenever bright clouds (and other white objects) are included in an overexposed picture, they can become pure white, as seen here. The only solution is to make them just less than pure white, but this will never produce a good result. Alternatively, we could replace the entire sky!

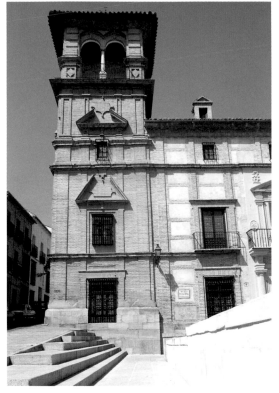

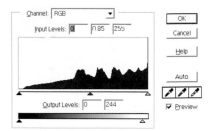

Applying Levels

This screenshot shows the Levels dialog box used to correct the tower picture. Note the use of the white slider in the Output Levels, which has reduced the brightness of the wall and steps.

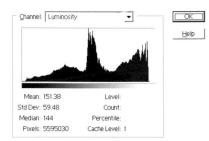

Corrected plaza tower

The image after applying the Levels command using the settings shown in the screenshot (right). Each picture requires unique settings, so use your own judgement when using the Levels command.

Corrected histogram

The final histogram shows how the tones have been changed. There are now more dark tones on the left of the graph.

Contrast problems

The level of contrast in a scene is mainly dictated by lighting conditions, and is generally referred to as high, normal or low contrast. Bright, sunny days with plenty of clear blue sky often produce a high contrast. Sunny days with white clouds floating in the sky produce a less harsh contrast, because the sunlight bounces off the clouds. Dull, overcast days, with no sunshine at all, produce the lowest contrast.

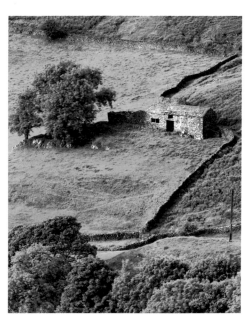

Hillside: original shot with low contrast

This shot was taken using a long lens on a hazy day. The result is low overall contrast, making the image lack sparkle.

Hillside with increased contrast

The Levels command allows the contrast to be corrected. In this case, the contrast has been increased and the image now has more "bite".

Low-contrast histogram

The histogram of the image shows how most of the image tones are compressed in the middle of the chart.

Using the Levels command

To correct the contrast in an image, move the Input Levels sliders. These black, grey and white triangles control the tonal values of the shadows, mid-tones and light tones respectively. Take care not to overdo these adjustments, or you may ruin the image. If your software allows Adjustment layers, use these to preserve the quality of the original image pixels.

Often, high- or low-contrast lighting conditions produce less than satisfactory pictures. High-contrast pictures look harsh and dramatic, whilst low-contrast pictures tend to look dull and lifeless. These two image problems can be corrected, to a large degree, with image manipulation software. Low contrast is the easiest to fix because the image usually contains good detail in all areas. High-contrast pictures have little or no detail in the dark shadows with which to work.

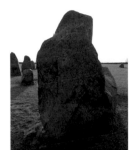

Dealing with high contrast

For high-contrast scenes, it is difficult to improve the original picture because of a lack of image information. A better solution is to take two pictures from the same position, using a different exposure for each one, as shown here. I exposed separately for the sky and the main rock.

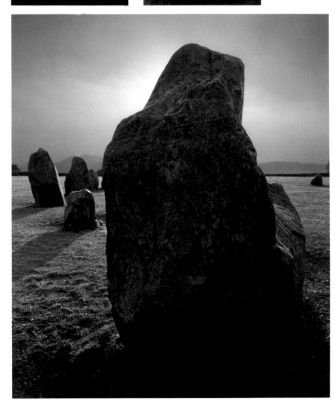

Castlerigg stone circle

The final image is a composite of the two pictures. To make a composite, use the Layers facility of your software, and copy each image on to a separate layer in a new file. Use the selection tools and the Eraser to remove the unwanted portions of each image. If the software uses layer masks, it is easier to paint on the layer mask of the top image to hide unwanted areas, rather than to erase the image itself (see screenshot below).

Correcting colour

Colour correction can never be an exact science, since everyone will see the same colours slightly differently. Add to this, the problem of reproducing colour with different types of equipment, and it becomes clear that colour is a highly subjective issue.

When working with colour, the golden rule is to use your own judgement, but before making colour balance adjustments, always correct the contrast of the image (see pages 18–19), because this will affect the appearance of the colours in the picture.

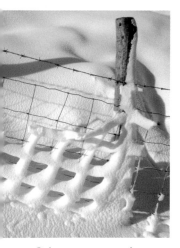

Snowy fence: original shot

When a subject – such as this snow scene – contains predominantly neutral tones, our eyes can tell instantly if the colour balance of the picture is wrong. This type of overall colour cast can be caused by the automatic white balance of a digital camera producing the wrong result.

Checking colour cast

The Eyedropper tool and the Info palette are used to assess the colour cast of a picture. In this picture, the colour cast is mostly red.

Using the Color Cast Correction command

These screenshots show the use of the Color Cast Correction command (in Photoshop Elements) to remove the colour cast. I have chosen an area of the image that is around the middle tonal range (K: 35–50% in the Info palette), and clicked the Eyedropper on this spot. It has made the spot neutral by removing the dominant colour and equalizing the RGB values. Note the red circled areas of the dialog boxes.

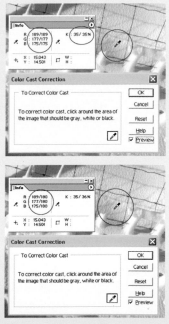

Color cast removed

The final image shows the result of using the Color Cast Correction command to remove the dominant colour cast and produce a more natural result.

Many images suffer from an overall colour cast. This affects all the tones of the image and is often seen most clearly in whites and greys – for example, white clouds may look slightly pink. Adobe Photoshop Elements has a Color Cast Correction command that uses the Eyedropper tool to remove a colour cast from a selected white, grey or black tone.

For more advanced colour correction, use either the Variations command or the Hue/Saturation command, each of which allows you to make dramatic changes to the colours of a photograph. The Variations command is probably the easier of the two methods.

Study in curves: original shot

This shot was taken inside a shopping centre lit by a combination of natural and artificial light, which can cause unusual colour results. For this type of problem, it is better to use the Variations command to correct the colours, because this method allows you to make different colour changes to each part of the tonal range of the image.

Variations dialog box

The Variations dialog box shows the effect of applying several different colour corrections. Controls at the top of the dialog box allow you to alter the tonal values and lighten or darken the image as desired. To correct the red colour cast of this image, I have added cyan to the mid-tones.

Study in curves: done!
The final corrected picture, showing more pleasing and natural colours.

Improving sharpness

The concept of sharpness is not as straightforward as you may imagine. There are technical definitions of sharpness, but what really matters is whether the picture has the sharpness you desire.

Digital cameras do not produce the high degree of sharpness that we have come to expect in a photograph. Therefore, before printing, it is usually necessary to apply overall sharpening to an image. The easiest method of doing this is to use the Unsharp Masking filter or USM. This filter increases edge contrast, producing a perceived increase in picture sharpness. To determine the amount of USM required, view the picture at 100%

size and adjust the settings as you watch the real-time preview. The larger the file size, the more USM can be applied.

A more advanced sharpening method involves using the High Pass filter. This is useful for trying to rescue pictures with severe sharpness problems. The High Pass filter only sharpens actual detail and not areas of smooth colour or tone. It also minimizes the accentuation of digital graininess in areas of smooth tone that is associated with USM.

Sharpness is also an important compositional tool that can be used to influence a viewer's interpretation of an image (see *pages 60–61, Playing with Focus Effects*).

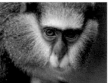

Monkey face – original shot

This picture has poor sharpness, due to three problems encountered whilst shooting: minimal depth of field, a long, two-second exposure time because of poor light (when the animal wasn't perfectly still), and having to shoot through thick glass that wasn't clean.

High Pass filter

For the greatest flexibility, I have chosen to use the High Pass filter method. To do this, create a new layer by dragging the background layer to the New Layer button on the Layers palette. Apply the High Pass filter (found on the Filters/Other menu): the higher the Radius value, the more severe the sharpening. Lastly, change the Blending mode of the layer to Hard Light (you may also remove colour from the High Pass layer with the Remove Colour or Desaturate commands). The High Pass filter dialog is also shown here.

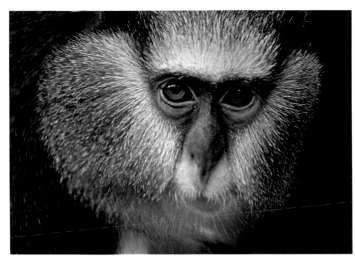

Monkey with High Pass filter

In the final picture, I have burnt in some areas by painting with a soft Brush on a new layer (this allows corrections if needed). I have also deleted some areas of the High Pass filter layer to localize the sharpening on the face and create more of a differential focus effect. The final Layers palette is shown with the picture.

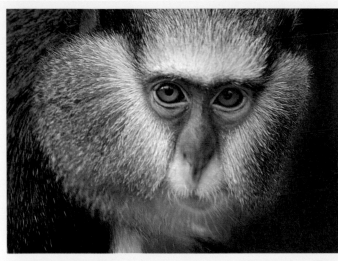

Monkey with USM

This example shows the use of quite heavy USM sharpening to achieve an acceptable result. The main difference between this and the High Pass filter method is that this image has become very grainy (not easily apparent at this size). The values used for the USM are shown in the accompanying dialog box.

Fixing tilted images

No matter how careful you are when using your camera, at some time you will hold the camera at a slight angle, resulting in a tilted image. This will be especially apparent in shots of buildings and seascapes (where a tilted horizon will make the sea seem to pour off the edge of the picture).

To fix a tilted image, it is necessary to rotate the image on the canvas; the

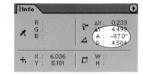

Window display: original shot

This interior shot of a shopping complex was taken hastily and has resulted in a tilted image – the columns should be vertical.

Determine the angle of tilt

To work out the angle of tilt, use the Line tool to draw a line along an edge that you know should be either vertical or horizontal (here I have used the corner of the main column on the right). The angle of the line can be seen in the Info palette. Note the angle and then undo the Line tool to erase the line just drawn.

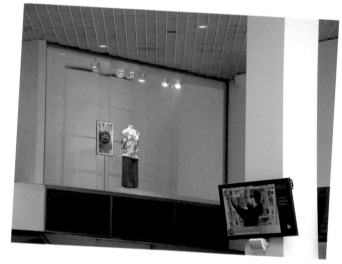

After rotation

Using the Rotate Canvas Custom command in Photoshop Elements, subtract the angle of the line from 90° to obtain the rotation angle needed, and enter this in the dialog box. Because we are rotating the whole picture, excess white areas remain.

problem is determining the amount of rotation required to correct the tilt. Some image manipulation programs provide measurement tools that allow you to find the distance and angle between two points in an image, work out how much an image is tilted, and provide the exact rotation angle needed to fix the tilt.

For software without a specific measurement tool, such as Photoshop Elements, you can use the Line tool and the Info palette angle display to determine the angle between two points. This angle is then used with the Rotate Canvas Custom command to obtain an exact correction of the tilted image.

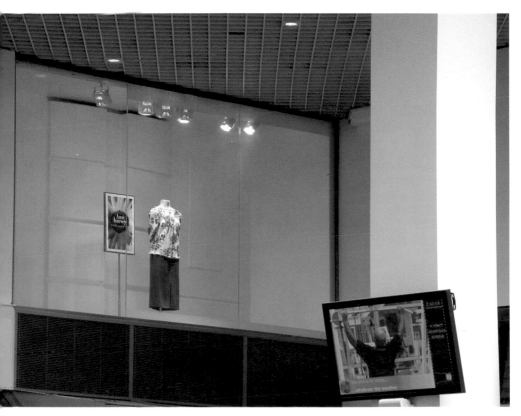

Crop final image

Use the Crop tool to remove the unwanted white parts of the image. It is an unfortunate side-effect of cropping that some important detail may be lost at the edges of the picture.

Fixing convergence

Perspective, or convergence, allows us to see the world in three dimensions. We are able to determine depth because the parts of an object that are closest to our eyes appear larger than the parts that are further away. For example, when we look at a building from one corner, its height appears to diminish as the walls of the

Spanish church: original shot

This church was photographed from slightly to the left of centre with a wide-angle lens and the camera pointing upward. The upward angle has resulted in acute convergence towards the top of the building, whilst the off-centre viewpoint has produced uneven distortion of the sides of the church.

Correcting distortion (right)

When correcting convergence, extra space is needed around the picture so that the edges of the subject are not clipped. First, increase the size of the picture canvas using the Resize/Canvas Size command. Next, make the grid active using the Show Grid command on the View menu. This will provide horizontal and vertical reference lines to help with shape correction. Now, using the Distort Transform (or Free Transform) command, pull the corners of the picture to correct the distortion.

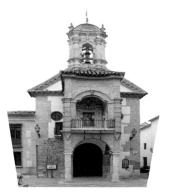

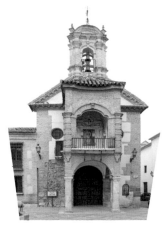

Using Distort Transform

This screenshot shows the rather large corrections needed. You can see why it was necessary to enlarge the canvas to make room for the transformation. Note also that more correction was needed on the right side of the church because of the asymmetrical convergence.

Correcting aspect ratio

To make the church look more natural, I have used the Distort tool to stretch the church vertically until it looks more like the original. Once the picture is cropped to shape, there will be empty white space left in the corners.

building get further away (and the bricks appear smaller). A camera works in the same way – if an object is at an angle to the lens, the distant parts of the object tend to look smaller than the parts near the camera.

When a camera is pointed up or down to photograph a building or other vertical object, the resulting photograph will show convergence. Although convergence is a natural visual effect, it can make a photograph of a building look wrong, because our brain knows that buildings have parallel sides. Image manipulation software can be used to fix this problem.

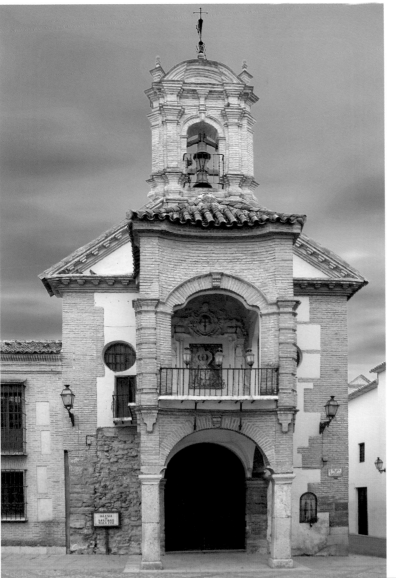

Iglesia de Santiago

To achieve the final image, I have cropped the picture to shape and then used the Clone tool to fill in the white space created by the Transform tools. I have also added a new sky to replace the blank white one of the original.

Removing unwanted objects

There will be many occasions when you photograph a scene only to later discover that there is something in the shot that spoils the picture.

The main tool for removing unwanted objects is the Clone tool. This is a very powerful feature of all image manipulation software, and it is a good idea to master its use quickly, because you will be using it extensively.

The Clone tool works by copying one area of an image over another, and is

Telephone boxes: original shot
This picture has several unwanted items, the worst of which is the signpost that cuts through one of the phone boxes. There are three problems to solve: the upper part of the post crossing the phone box, the lower part of the post on the pavement, and the white paint on the road. The shot also suffers from some lens distortion.

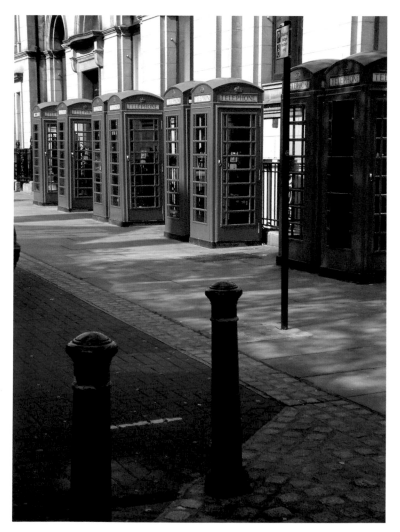

mostly used to remove unwanted details from the current image. However, it is also used to clone objects from one shot to add to another.

When cloning, it is important to avoid creating a repetitive pattern, because the eye will be able to detect such patterns easily. The best way to do this is to make cloning as random as possible by using lots of new cloned selections (use Alt-click to make each selection).

When an image contains several similar objects (as is the case here), it is possible to get rid of an offending object by copying a good example and moving it over the object which is be disposed. This is then blended using the various painting tools.

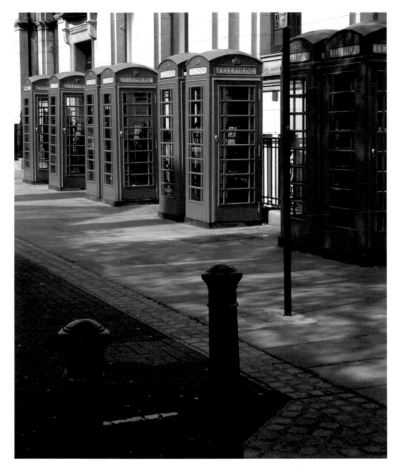

Shaping and cropping the shot
Here the Perspective Transform tool has been used to reduce the lens distortion, followed by the Crop tool to remove unwanted edge items and make a stronger composition.

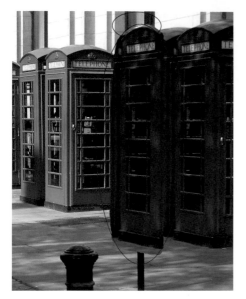

Copying an object

To eliminate the signpost crossing the phone box, I have used the Lasso tool to make a rough selection around the "good" phone box on the right, and copied this to a new layer. The Transform Distort tool is then used to make this copy the same size and shape (to allow for perspective) as the "bad" box that is to be covered. The same technique is used where the signpost obscures the window above the phone box.

Layers palette

This screenshot shows the Layers palette so far. Note that the window layer is below the phone box layer, because I want the window to appear behind the phone box.

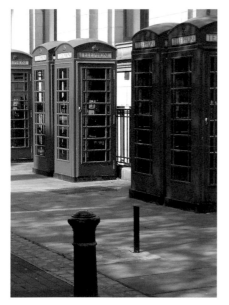

Reshaped telephone box

Here's the result of reshaping the telephone box. The problem is that we now have two phone boxes with identical light and shade. This can be corrected by using the Dodge and Burn tools to change the pattern of light and shade on one of the boxes.

Cloning the pavement

I have chosen to use the Clone tool to eliminate the bottom of the signpost because it is ideal for areas with random patterns, such as this pavement in dappled light. (If there are any lines in a picture, such as the edges of the stones here, be careful to align them correctly.)

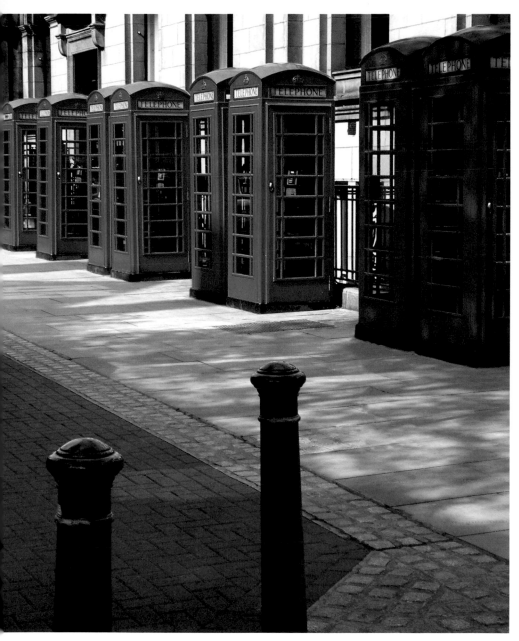

Perfect telephone boxes

In the final image, the signpost has been eliminated, and the white paint and marks on the road have been cloned away. Note also how I have deleted areas of the cloned phone box where you would expect to see through the glass. Further tonal adjustments have been made to complete the image.

Getting creative

This chapter explores the more creative aspects of digital image manipulation. It starts with a grounding in the basics, including essential skills, such as the use of selections, layers and filters. It is important to spend time mastering these techniques so you fully understand how they can be employed in your own pictures. Then you will be ready to have a go at the range of topics covered in this section.

Although some of the final results may appear to be complex, they all use fairly simple methods that are easy to learn and apply. The techniques described are only a starting point for exploring your own ideas and methods of achieving the type of pictures you want. As you experiment with different tools and features your confidence will grow allowing you to go further than you ever thought possible. The main thing is to have fun while you learn!

Greek wrestler

A detail from a shot of a statue of a Greek wrestler, which has had colour and various filters applied to create this semi-abstract picture. It is great fun simply playing around with various effects, as I have here, until you arrive at a result you want to keep.

Making selections

The techniques in Chapter 1 dealt mainly with altering the whole image, but there will be many occasions when you want to modify only a portion of an image.

To isolate a portion of an image, special selection tools are used to draw around the required part. This creates what is known as a selection or mask. A selection is shown on the image by a moving broken line known in trade as "marching ants".

There are various tools and techniques for creating different selection shapes,

Geometric shapes

The Rectangular and Oval Marquee tools allow you to define regular rectangular or circular geometric shapes. More complex selections can be made by using these tools in combination to add or subtract one shape from another. To add to an existing selection, hold the Shift key down; to subtract from it, use the Alt key.

Magic Wand tool

The Magic Wand tool is used to select areas based on colour. It is ideal for well defined shapes. When it is clicked on a pixel, it creates a selection that includes adjacent pixels of a similar colour. A tolerance setting, entered in the Options palette, fine-tunes the selection. Here the tool has been used to select areas of the red ball.

Polygonal Lasso tool

The Lasso tool is great for drawing freehand shapes, but to select straight edges, it is easier to use the Polygonal Lasso. To use the tool, click with the mouse to fix a point and drag the tool to the next point. To finish and close the selected area, either click again on the starting point, or press the Enter key. Here a box is being selected.

Photoshop Elements 2

Unfortunately, Photoshop Elements 2 does not have a Save Selection command, but you can work around this omission. Create a new layer, make it active, then draw your selection as normal. When the selection is ready, make sure the foreground colour is black and use the Edit/Fill command to fill the selection with black. Name this layer and click the Eye icon to make it invisible. When you need the selection again, simply hold down the Control or Command (on a Mac) key and click on the selection layer. This will load the layer as a selection. Add or subtract other selection layers by holding down the Shift or Alt key before pressing the Control key.

depending on what you need to isolate. Note that each time you start a new selection, any existing selection is lost.

Often, complex selections are required, which can take quite some time to make, so it is useful to save them. Most image manipulation software allows selections to be saved and reloaded. A saved selection is known as an alpha channel or channel mask. Once a selection has been saved, it can be loaded again whenever you need it. You can load more than one saved selection at a time, and combine them in various ways. Saved selections are stored as part of the image when the image file is saved.

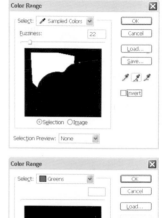

Magnetic Lasso tool

The Magnetic Lasso tool is used to select almost any shape with well-defined edges. Simply click once to start and drag the mouse along the edge to be selected. The tool creates lots of points along the edge of the object.

Colour Range command

This is useful when you only want to select certain colours in an image. Either allow it to select a specific colour (such as all reds), or use the Sampled Colours option to pick the range of colours with the mouse. Use the three Eyedropper icons in the command dialog box to add or subtract colours (see screenshots). This command sometimes also selects areas you do not want, so use the Lasso tool to remove them, as shown.

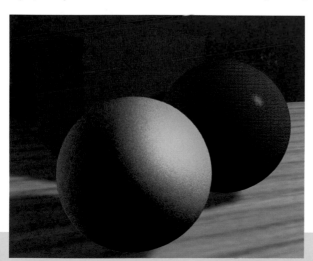

Working on selected areas

Creating selections allows you to make changes to specific parts of an image. This simple example shows how different filters have been applied to each of the geometric shapes, by using a selection to isolate each shape.

Working with layers

Layers are another important feature of image manipulation programs, which you need to understand. The Layers palette is used to control the layers in an image.

Think of layers as being like a stack of clear plastic sheets piled on top of each other. Each layer can have different images (or text) placed on it, and it is independent of

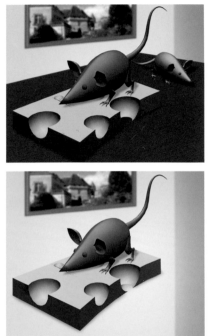

Mice and cheese

This illustration has been created to show layers in action. Each element – walls, window, tabletop, cheese and each mouse – is on its own layer. This is the best way to make a composite picture. The screenshot shows the Layers palette and the order of the elements.

Hiding layers

This version shows the result of hiding the layers for the table and small mouse. To hide a layer, click on the Eye icon in the Layers palette. To show a hidden layer, click in the box where the Eye icon should be. The modified Layers palette is shown.

Special layers

There are three special types of layer – Adjustment, Type and Shape. The most commonly used of these is Adjustment. An Adjustment layer allows changes to be made to the layers below it in the stack without altering the actual image data. This permits infinite adjustment of things such as Levels and Colour Balance.

The Type tool is used to create a Type layer. Type layers allow you to edit the text at any time. If you want to apply filters to create

special effects with the text, it is necessary to rasterize the Type layer. In Photoshop Elements, this is done using the Simplify Layer command on the Layer menu. (Rasterization is the changing of a file into the pixel-based image type required by Photoshop.)

Shape tools are used to draw filled geometric shapes such as rounded rectangles and circles. Like a Type layer, each shape is placed on its own Shape layer so that it can be edited as desired. If you want to use filters, the layer must first be simplified, as for a Type layer.

other layers. Empty parts of a layer are transparent, so anything on the layer(s) beneath it will show through. In this way, multiple images can be combined to form photomontages.

An image layer can also be made to interact with the layers beneath it, using

Blending modes. Blending modes are often the key to creating different effects when combining images. The Layers palette allows you to make new layers, name layers, delete layers, change the layer order, adjust the opacity of the layer, and merge selected layers.

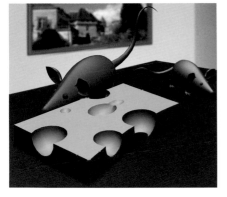

Layer order

The order of the layers in the Layers palette can be changed by dragging a layer up or down the stack. As this example shows, it allows you to change the way elements in the picture overlap. The Move tool can also be used to reposition a picture element within a layer – here I have moved the large mouse next to the cheese. The accompanying screenshot demonstrates how the Layers palette has changed.

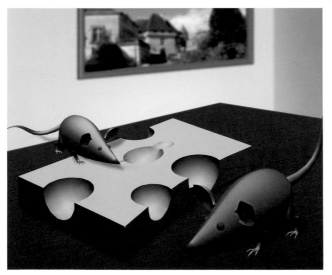

Merging layers

To save memory and be more efficient whilst working on a multi-layered picture, two or more layers can be merged together. To do this, link them by making the first layer active, and then click in the Link Layer box next to the Eye icon. Next use the Merge Linked command from the Layers palette menu. Only merge layers when you are absolutely sure you have completed work on those layers. The much reduced Layers palette is shown.

Resizing digital pictures

The maximum size of a digital picture file is initially determined by the capability of the digital camera. However, you may want to change the size of a picture, either to obtain a different print size or to make it fit into a photomontage. Changing the size of a picture file is called resampling or interpolation.

Whenever the size of a digital file is increased, the software must "invent" new

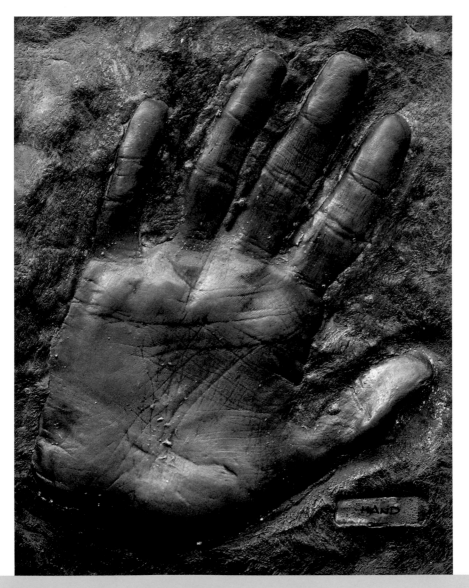

information to insert in the file, based on the tone and colour of the existing image pixels. Since this new information is not "real", the bigger the digital file is made, the worse the quality of the picture becomes, with a loss of sharpness and a general deterioration of picture details. Reducing the picture's file size requires the software to remove information from the image, resulting in a loss of detail although the image may appear sharper.

However, size reduction doesn't cause the same apparent loss of quality that results from a size increase.

Reducing the size

By reducing the original to a size of 2 in x 1.5 in (50 mm x 38 mm), at the same resolution of 300 dpi, we obtain a smaller print, but one that is of good quality.

Increasing the size

This small section of the picture shows the result of increasing the size of the original to 30 in x 24 in (762 mm x 609 mm), at 300 dpi. Notice that increasing the picture size has produced much softer image details.

Metal hand: original shot

This is the original picture at a size of 6 in x 4.8 in (152 mm x 121 mm), and a resolution of 300 dpi (dots per inch). This is suitable for optimum print quality at full size (the reproduction here may not be full size).

Artistic filters

One way to explore the creative possibilities of digital imaging is to play around with the special effects filters provided by the image manipulation software. These filters are generally found under the Filter menu and grouped according to the type of effect produced, for example Artistic, Blur, Distort, Noise, Render, and Sharpen.

Most filters display a dialog box showing a small preview window and various user-controlled settings that determine how the filter will react with the image. It is great fun getting to know each filter's capabilities and seeing the result on your picture. You can reverse the effect of a filter with Edit/Undo or the History palette.

Additional filters, known as filter plug-ins, can be purchased from various sources. Once installed, these appear on the Filter menu just like built-in filters.

The examples shown here demonstrate the effect of filters from the Artistic group in Photoshop Elements. (*See also pages 56–57, Creating a Work of Art.*)

Rhinos: original shot

The Artistic filters are designed to produce effects that emulate traditional painting techniques. The original unfiltered picture is shown here; various filters from this group are applied in subsequent pictures.

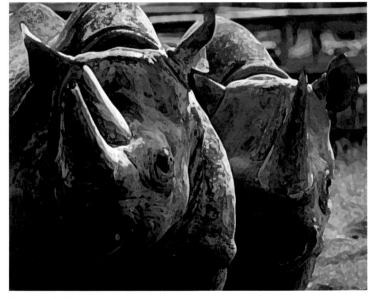

Dry Brush filter

By using a brush with very little paint on it, artists can produce a fairly sharp picture but with flattened colours. The results depend on the size of the brush and how it is applied. The digital Dry Brush filter simulates the traditional method, allowing many possibilities. It provides controls in a dialog box (like most of the other filters).

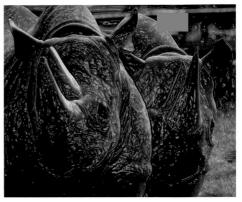

Palette Knife filter

Unlike the Dry Brush filter, the Palette Knife filter produces a softer result, simulating the application of thick paint. The tones and colours blend together rather like paint on a canvas.

Plastic Wrap filter

This filter simulates an effect that artists produce by manipulating the surface of SX70 Polaroid prints to form unique painterly images – in this case, a result that looks like melted plastic.

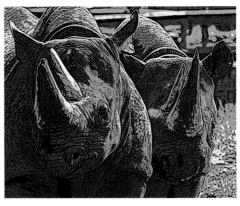

Film Grain filter

Traditional film photographers have long used the "grain" produced by fast film as an artistic effect. Because pictures made with a digital camera have very smooth tones and colours, many people like to add simulated film grain to give the picture a traditional "gritty" feel.

Poster Edges filter

Use this filter to achieve the look of a pen and ink drawing – it emphasizes the edges of details in the picture. It is a bold effect, giving a poster-style result.

Distort filters

This set of filters produces some unique and wonderful effects. The filters move the pixels of the picture around to create various results, usually based on wave patterns or a swirling movement. Only a few examples are shown on these pages.

As with all filters, it is best to experiment on different pictures until you obtain a result you like. Remember, also, that you can combine different effects by applying more than one filter to a picture.

**Sunflowers:
original shot**

As the Distort filters literally move a picture around, it is best to apply them to a photo with bold colour and good detail, such as the unfiltered original shown here.

Ripple filter

The Ripple filter applies a rippled pattern to edges in a picture. I have exaggerated the effect here to demonstrate the filter, but it can be used to produce quite subtle results. The size and amount of ripple is set before applying the filter. This filter can be used to simulate the surface of a lake.

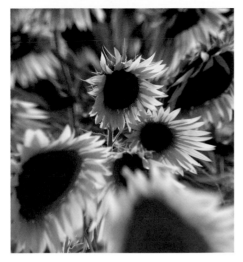

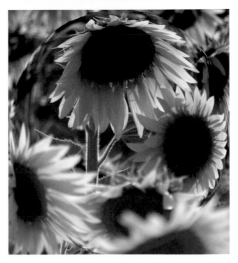

Pinch filter

The Pinch filter can be used either to pull picture details towards the centre, or make them bulge outwards. In this example, the outer areas have been pulled towards the centre (without affecting the central flower), thus drawing the viewer's eye to the flower in sharp focus.

Spherize filter

The Spherize filter allows you to create the effect of looking through a magnifying glass (in fact this is how to create a magnifying glass digitally). The apparent thickness of the glass is controlled by the parameters set in the Filters dialog box.

Glass filter

The Glass filter allows you to simulate a vast range of glass effects, such as frosted glass. This example, glass blocks, is one of the more extreme but very effective results.

Wave filter

A more advanced form of the Ripple filter, it is capable of extreme distortions, and can produce unusual designs. I placed a copy layer of the original above the filtered version and used a layer mask to hide unwanted areas.

Stylize, pixelate and sketch filters

The filters on these pages are taken from three other groups: Stylize, Pixelate and Sketch. All manipulate the pixels of a picture. Remember that some filters are designed with fairly specific types of work in mind, such as creating text effects for publishing, and may seem rather over the top for normal pictures. However, it is always worth experimenting with the various layer blending methods to combine filtered and unfiltered images. The main problem with filters is knowing when to stop – but that's half the fun of using them!

Boats: original shot

Many filters produce somewhat bizarre results, so it can be useful to start with a picture that is bold in composition and colour. This unfiltered shot of a children's boating lake at a fairground is almost abstract to start with, and lends itself to manipulation with the more unusual filters.

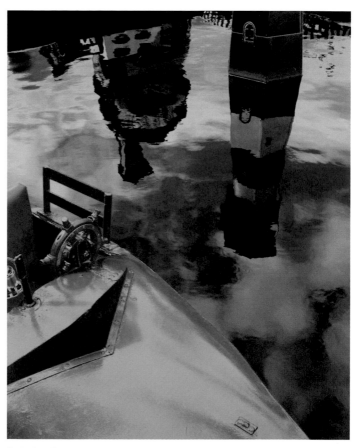

Solarize filter

The Solarize filter simulates a traditional photographic technique, reversing the tones of the lighter areas of the picture. With colour images, it also reverses the colours – as seen here. This has produced a very "pop art" poster look, with surreal colours.

Crystallize filter

The Crystallize filter simulates the effect of crystal glass by breaking the picture into uneven patches of colour. This filter destroys detail in the image, but emphasizes bold colours.

Stained Glass filter

This filter breaks the picture into patches of colour; it also adds black lines between the patches to simulate the lead in a stained glass window. The patches and the width of the lines can be varied.

Glowing Edges filter

This unusual filter makes any edges in the picture into brightly coloured, uneven lines. The image looks as though it has been drawn with coloured torches. It can be combined with other filters to good effect.

Chrome filter

A combinination of a filtered picture with an unfiltered version. The filter simulates chrome metal, but produces a greyscale result. Hard Light Blending mode has been used on the chrome layer.

Selective colour changes

It is possible to make a variety of enhancements by selectively changing the colour of parts of an image. For example, you could change the colour of objects in a scene to improve the overall picture, or completely alter the look of a picture.

The first step is to define the area to be changed using the selection tools. Use the Hue/Saturation command to change the colour of the selected area – it gives you good control over the colour, saturation and brightness of the colour change.

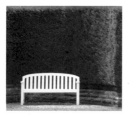

White bench

This lonely white bench against a green hedge is a perfect candidate for having some fun with colour changes. This is how to do it. Make a selection of the bench (I have used the Magic Wand) and copy it on to a new layer using the Layer Via Copy command on the Layer/New menu. Remove any colour cast from the new layer with the Remove Colour command.

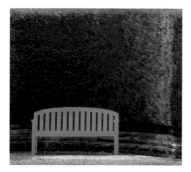

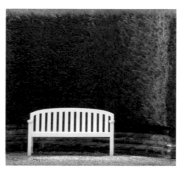

Yellow bench

By making several copies of the original white bench layer, various colour changes can be made in order to determine which one you like best.

Magenta bench

There are various ways to change a colour, but one of the easiest is simply to paint over the object on the layer. Make sure that the Lock Transparent Pixels box on the Layers palette is checked, so that the paint is restricted to the object, and then simply paint all over the object. I have used magenta, with the Brush set to 60%. The Blending mode of the layer is then set to Multiply so that the tonal values of the bench are retained.

Layers for the painted effect

This shows the Layers palette with the magenta and yellow layers. Note that the Lock Transparent Pixels box is ticked, so that any painting only affects the bench.

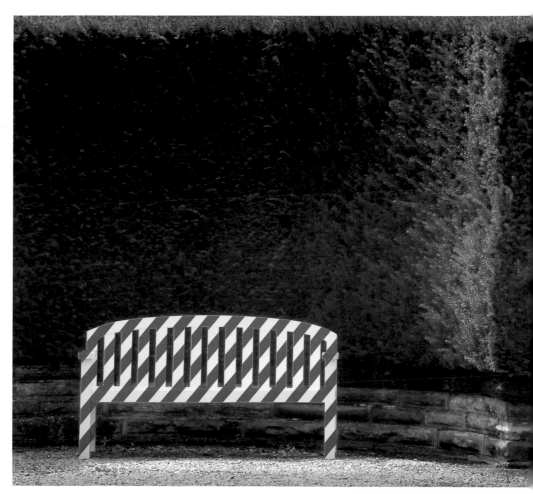

Pop Art bench

You can even create a pattern on your object. For this 1970s "Austin Powers" look, I have created several angled black stripes on a new layer, using filled selections. The stripes are used as a selection (Control-click the stripes layer) to cut away part of the magenta bench. The selection is then inverted and used to cut away the opposite parts of the yellow bench, so that each colour will be on only part of the final bench, producing this striped effect.

Layers for the striped effect

Here we see the Layers palette for the Pop Art bench. The stripes layer is used to create selections that control which parts of each coloured bench are deleted – the yellow bench has gaps where the magenta bench shows through.

Colouring images

Before the invention of colour photography, the only way to achieve a colour picture was to hand-colour it. Even today, many skilled photographers hand-colour black and white photographs using dyes, oil paint and various other art mediums to produce a unique look.

Fortunately, digital hand-colouring is very easy to do and requires far less skill. Using the Colour Blending mode, you can apply colours over a black and white image to produce interesting effects. The Colour Blending mode retains the underlying tones of the image, so you don't need to worry

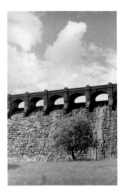

Converting the original

If the original is black and white, such as this shot of a dam, it must be converted to RGB mode to allow colour to be applied. A colour original needs to be desaturated to convert the image to a black and white RGB image. Use the Desaturate command to do this.

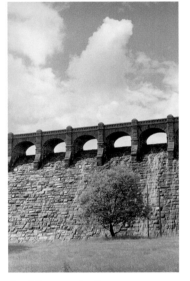

Applying a sepia tint

Traditionally, prints to be hand-coloured were first sepia-toned to produce a mild overall colour effect. I have reproduced this effect by creating a new layer, and using Colour Blending mode to fill it with a light brown colour. The full tonal values of the image are retained. The sepia tint ensures that unpainted areas, such as the clouds, have some colour.

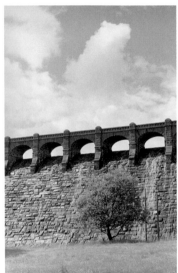

Applying individual colours

When you start to "paint" a picture, create a new layer for each colour and set it to the Colour Blending mode. If the area to be coloured is complex, such as the sky in this picture, use the selection tools to isolate the colour effect. Here, the grass simply needs a soft-edged Brush to apply the colour. The dam walls need to be selected with the Magic Wand tool, and the complex blue sky requires the Colour Range command in order to paint the subtle edges of the clouds correctly.

about changing colours to obtain shadows and highlights.

Both colour and black and white pictures are suitable for hand-colouring. With a colour picture, first use the Desaturate command to remove the original colour. With a black and white picture, it is necessary to first convert it from greyscale to RGB, or you won't be able to apply colour.

There are two methods: either use a Paintbrush in colour mode and paint directly on the original image, or create a new layer above the image and set it to Colour Blending mode. The latter method is better, because it allows you to correct your work without ruining the original image. If using several colours, create a new colour layer for each, to permit fine control of the colour without affecting other colours.

Autumn tree and dam

To make the tree look autumnal, I have made a rough, feathered selection around the leaves with the Lasso tool, and painted the various colours with a soft Brush. This array of colours is then mixed by applying the Gaussian Blur filter. By using a new layer for each main colour in the image, I am able to adjust the strength of the colours through the Opacity setting of each layer. (The opacity of the Brush can also be adjusted, for further control.) The final arrangement of layers is shown in the screenshot.

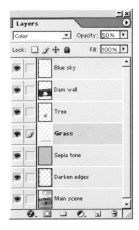

Making a photomontage

Montage is an artistic technique that is used extensively to create surreal or fantasy images, which are made up of a combination of pictures. Digital imaging has made photomontage very easy – now anyone can produce complex images composed of many pictures. The process relies heavily on the use of layers. Each picture or text element is placed on its own layer and manipulated as desired to build up a finished picture.

There are two main ways of working. If you would prefer to plan out your photomontage, draw a rough sketch on

Background picture

Select a suitable background image for the photomontage and make any tonal and colour balance adjustments. (This sky picture was uneven in tone across the diagonal and had a strong cyan colour cast in the clouds, so these problems have been corrected before other elements are introduced.)

Introducing elements

Open the image files for the elements you wish to insert in the montage, and copy them to the background picture on new layers. (Here I have introduced two pictures of hang gliders.) Use the Move tool to position the elements in the composition. (I have duplicated one of the existing layers in order to have three hang gliders in the final composition.)

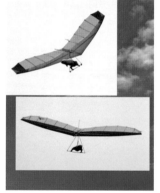

Organizing elements

Work on each element as required. (I have rotated and scaled each element, using the Transform tools to create the required perspective and sense of movement. To make the two identical gliders different, I have also added bright red to the wing of the largest element by painting with a soft Brush set to Overlay Blending mode.)

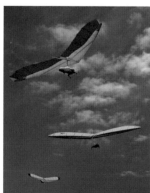

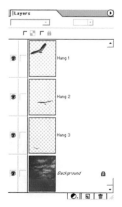

paper of how the elements will interact in the final piece and scan this into the image manipulation program to use as a blueprint (place the scan on the background layer). If you want to take a more intuitive approach, just start putting various pictures on their own layers and explore the possibilities to see where it leads you.

Once the individual elements have been copied and pasted into separate layers, each element can be moved, rotated, resized, distorted or otherwise altered to obtain the final composition. Other factors to explore are layer Blending modes, changing layer opacity and using layer masks to control which parts of each picture element will be visible in the final image. All these controls can be applied to each layer separately, giving an infinite range of possibilities.

Completed photomontage

To further enhance the impression of depth, I have applied a slight amount of Gaussian Blur to the two smaller hang gliders, with a little extra on the smallest one, as it is meant to be further away.

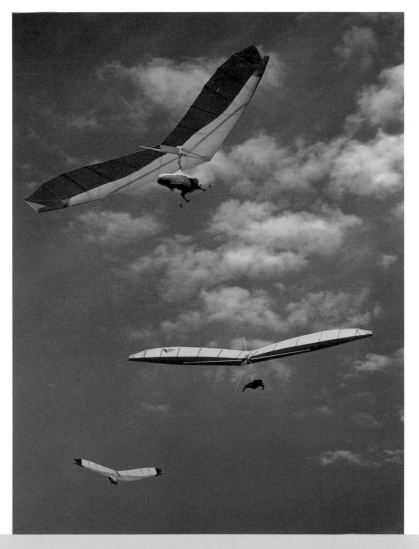

Creating a panorama

A panorama is a picture that shows a very wide field of view in one direction, usually horizontally, to capture a large area of a scenic view. Panoramas produce a print shaped rather like a letterbox, much longer than it is tall. They make the viewer feel more "inside" the image.

True panoramic pictures are made with a special camera that has a rotating lens; however, a similar result can be created with an ordinary camera and image manipulation software. The first step is to find a suitable scene to photograph. Try and find a scene that contains lots of interest.

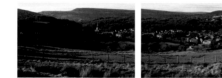 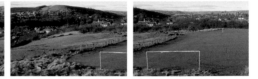

Photograph the scene

Take a series of pictures of the chosen scene. Be sure to use a tripod and allow a generous overlap of the subject on each picture, as shown in this four-image sequence.

It will be necessary to balance the tones of each image later, so make three different exposures of each part of the scene. (In this case, I had a total of 12 frames to work with.)

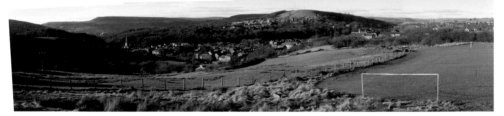

Composite the images

Choose the best exposure for each image and open them in your image manipulation software. Select one image and copy each of the other images into this file. Holding the Shift key down, drag each image from its Layers palette and drop it on the first image – the images will be perfectly centred. Close the unwanted images. With each image now on its own layer, double the width of the canvas using the Resize/Canvas Size command. Starting with the lefthand image, reduce the Opacity setting of the layer and use the Move tool to position it over the image second from the left. It will probably be necessary to use the Transform tools on the images to make them align accurately. Repeat until all the images are aligned.

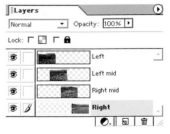

To create the panorama, decide the beginning and end points of the scene (you could also choose to do a full 360° panorama). Then, with the camera firmly fixed to a solid, perfectly levelled tripod, take a series of pictures with at least one third of the scene repeated in each picture (the pictures will need to overlap later to create the panorama). Rotate the camera carefully between each picture and make

sure you are generous with the amount of scene repeated in each shot. It is important that the exposure for each picture is consistent, so the final panorama will look balanced in detail and brightness. The best way to achieve this is to bracket the exposure for each shot – take at least three different exposures of each view. The final exposures can be balanced when creating the panorama.

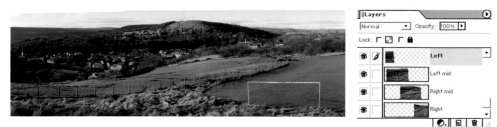

Crop the image

Use the Crop tool to define the area of the panorama that you want, and reduce the file size. Now, adjust the tonal and colour balance of each layer so they all match and look natural. The images blend better if you use a small,

soft Eraser to remove a little from the hard edges of each image. (Because my tripod had moved for the last image, I needed to rotate this shot quite a lot, resulting in missing sky. To correct this, I have used the Clone tool to extend the sky areas.)

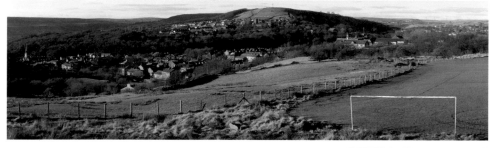

Valley panorama

Make any final adjustments to your panorama. (Here I have used the Gradient tool on a new layer above the picture to make the edges of the image darker.)

Using blending modes

Blending modes control the way that the colours and tonal values of different pixels interact with each other. There are two ways of applying a Blending mode: when using a Painting tool (such as a Brush or Airbrush), and when using layers. Most tools that apply colour can make use of Blending modes.

This is how it works. Each Blending mode uses the colour and/or tonal values of the pixels from a source (the blend colour) and applies these values to the pixel values already existing in an image (the base colour), thereby creating new

final values (the result colour). When operating a Painting tool in Blending mode, the colour on the Brush is the blend colour, applied to existing image pixels. When layers are used for blending, the new blend mode affects the pixels in the current layer and those in the layers beneath it.

Any layers above the current layer will be unaffected. The results of changing the Blending mode for either a layer or a Painting tool can be surprising and unpredictable, so experimentation is called for.

Normal

This is the straight picture in Normal Blending mode. To illustrate each Blending mode, I have placed a copy of the image on a new layer above and deleted the top half, so the top portion of each example shows the straight picture, and the bottom portion shows the changes made by the various Blending modes.

Multiply mode

When the Blending mode is set to Multiply, it darkens all the pixels. The lighter pixels in the new layer darken less than the darker ones, thus producing an increase in contrast.

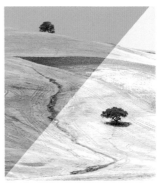

Screen mode

This is the exact opposite of Multiply mode. The whole image is lightened, with the lighter pixels in the new layer having more effect than the darker ones. This mode can be used to lighten shadows that are too dark.

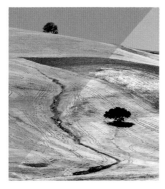

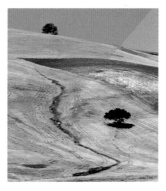

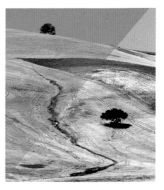

Overlay mode

This is a combination of the Multiply and Screen modes. In the new layer, dark pixels darken the layer underneath, and light pixels lighten the layer underneath; the result is enhanced contrast.

Soft Light mode

This is similar to Overlay mode, but it is more subtle in its effect. It is useful for gently adjusting the appearance of the lighting in a picture.

Hard Light mode

This too is similar to Overlay mode. It is useful for painting shadows on a picture (for example a portrait). By selecting a light colour and using the Brush tool, it is simple to paint in realistic shadows.

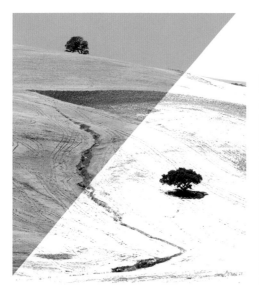

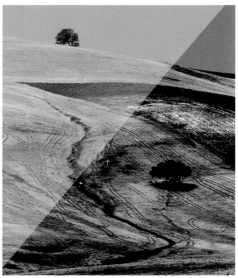

Colour Dodge mode

This mode lightens the base colour with the colours of the top layer. This can produce very bright results, which may be useful when garish colours are needed.

Colour Burn mode

The opposite to Colour Dodge mode – it darkens the base colour using the colours of the top layer. It is useful when well-saturated colours are needed to give a picture lots of punch.

Creating a work of art

Most image manipulation programs have a range of built-in filters that simulate various artistic media, such as pastels and coloured pencils, and painting styles and techniques such as palette knife, daubs of paint, watercolour, dry brush and smudging. Using these filters, it is quite easy to give photos an authentic painted look and to emulate the styles of great artists of the past. The results depend on the photo used and the way you specify the control options on the filters. It is also fun to try two or more different effects on the same image, to see what happens.

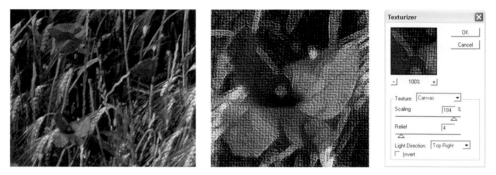

Canvas and oils

One of the easiest ways to simulate an oil painting is to add a canvas texture to the picture. Here I have applied the Paint Daubs filter first, to spread the colours and soften details, and then the Texture/Texturizer filter to create the canvas effect. This filter allows you to choose different surface textures and to scale the effect as shown in the screenshot of the Filter dialog box. The enlarged section shows the effect more clearly.

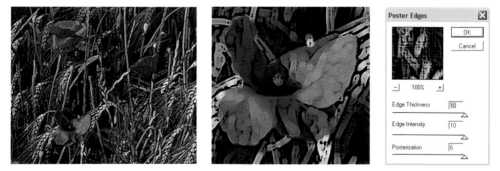

Graphic poster

Black edges outlining the details of a scene produce a very graphic effect, as demonstrated on theatre posters by Toulouse-Lautrec. To achieve this effect, apply the Poster Edges filter (after any other filter). I used the Paint Daubs filter followed by the Poster Edges filter, as shown in the screenshot of the Filter dialog box. Examine the enlarged detail to see the results.

You may wish to study a particular artist's style and try to analyze the effects that would be required to simulate the original technique. For example, oil paint may be applied thickly in order to give a three-dimensional, tactile effect. Watercolours are frequently very light in tone and colour, giving a luminous feel to the subject.

To create a painted look, choose a suitable photo and apply any image enhancements that will help produce the desired result. For instance, to create a watercolour you might choose a photo with large areas of colour but little detail, and then lighten the image to produce a more luminous colour effect before applying the Watercolour filter – experiment!

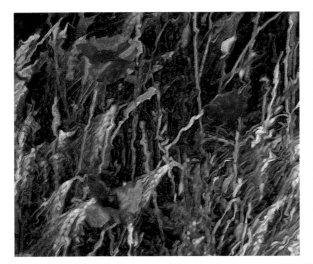

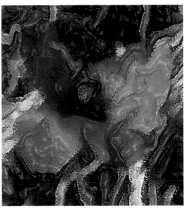

Impressionism

This version requires the application of three different filters and some hands-on work. First I have used my favourite filter, the Paint Daubs filter, to spread the colours and flatten details. Then I have applied the Rough Pastels filter to add texture and break up the smooth edges. (See the screenshots for the settings used with each filter.) To simulate the Impressionists' fluid style of paint application, I have then used the Liquify filter, with a Brush Size of 4, to hand-paint the image and move the pixels around. This layer is then duplicated by dragging it on to the New Layer button in the Layers palette. The Plastic Wrap filter is applied to the duplicate layer. Also, its Blending mode is set to Lighten, and Opacity to 70%.

Paint Daubs

OK
Cancel

100%

Brush Size 12

Sharpness 17

Brush Type: Simple

Rough Pastels

OK
Cancel

100%

Stroke Length 6

Stroke Detail 4

Texture: Sandstone

Scaling 50 %

Relief 20

Light Direction: Top Right

Invert

Surrealist art

Surrealist art often contains elements that look real but are depicted in unreal ways. It is typified by the imaginative, other-worldly pictures of the artist Salvador Dali. One of his most famous paintings contains a melting pocket watch. Digital imaging has given photographers the power to create similarly exciting images and express themselves in ways not possible before.

The digital creation of surreal pictures requires many different tools, and filters such as the Distort filter. Layers also play an important part. The best way to create a surreal image is to work out what you are trying to achieve, then compile the relevant photo elements into one file (on separate layers) and manipulate each as required.

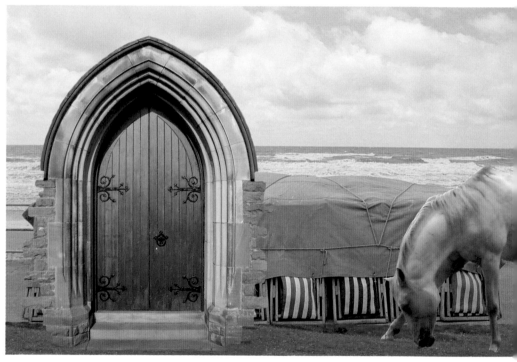

Assemble the elements

The first step in creating a surreal picture is to assemble the individual images on separate layers in one file. Use the selection tools to isolate the relevant element of each image, and delete the excess. If a selection is made with the Lasso tool, feather the edge by one pixel to help it blend with the other images. (You can see here that the horse and archway have been isolated in this way.)

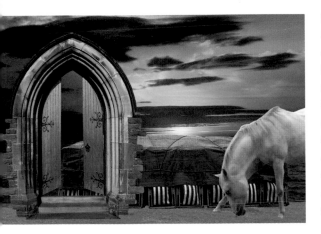

Modifying the elements

Once the elements are on separate layers and have been isolated from their original backgrounds, you can make any desired modifications. I have separated each door in the archway, and used the Transform tools to reshape them. The sky on the original picture has been removed, and a sunset and dramatic cloud formation added (the latter applied with the Overlay Blending mode). I have also added a strip of grass to the foreground to make the stance of the horse look more natural.

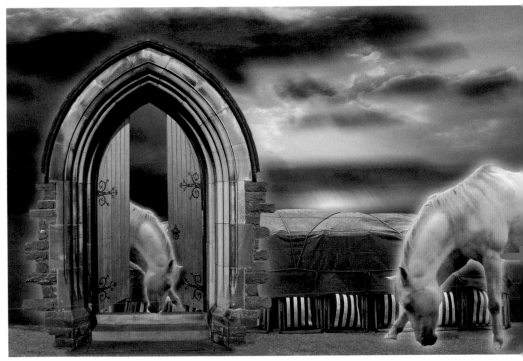

Surreal horses

A copy of the horse has been flipped, scaled down and repositioned between the doors. The horses have been coloured using the Hue/Saturation command with the Colorize checked. All the edges of the elements have been blended using the Eraser and Clone tools. Selective glows have been added using the Layer Styles, and the Motion Blur filter applied to the sky to create movement. Shadows for the horses and arch have also been created. After flattening all layers, a small amount of mild film grain has been applied.

Playing with focus effects

The way a picture is focused is a creative decision: it is based on what the photographer wants to portray in a picture. Because a 35mm digital camera can only focus in one plane, we rely on using the lens aperture to control how much of the scene is in sharp focus. The amount of sharpness in a picture is known as depth of field.

The main tools for focus effects are Blur filters, such as the Gaussian Blur. Gaussian Blur is used to apply a general out-of-focus look to all pixels in an image,

or a selection. Other filters, such as Motion Blur and Radial Blur, can be used to create special effects.

Unique focus effects can be produced by using selections with the Blur filters, and experimenting with different Blending modes. Using layers, multiple effects can be applied to copies of a picture and then integrated simply by erasing parts of each layer with a large, soft Eraser tool. The permutations for all these options are almost limitless.

Golden statue:
original shot
Pictures taken in bright conditions (as here) often have lots of depth of field, resulting in everything appearing sharply focused. Unfortunately, if the background is busy or dominant, it can detract from the main subject. To avoid this, we can simulate differential focus.

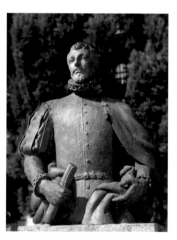

Differential focus
To simulate differential focus, isolate the background by making a selection and applying a Blur filter to soften the sharp details of the selected area. For a realistic result, it is best to apply the Gaussian Blur filter in small amounts. For this picture, I have applied Gaussian Blur five times, using a Radius value of 2 pixels.

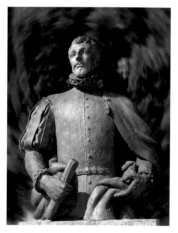

Motion blur
For a more creative approach, I used the Radial Blur filter on the background selection, with an Amount value of 6 and the Method set to Spin. To concentrate attention on the statue's head, I've moved the centre of the Radial filter by dragging the grid in the Blur centre box to where the head would be – causing the rotated blur to occur around the statue's head.

Poppy field: original shot

Moving firmly into the realms of digital exploration, Blur filters can be used to create Impressionist-style pictures. Starting with this simple but colourful picture of a poppy field, I have made two copies on new layers.

Blurred layer

Here is the result of using Gaussian Blur with a Radius of 40 (the Radius varies depending on the file size and the effect you want) on the middle layer. This blurred layer will be selectively combined with the layer above.

Poppy Impressionism

By changing the Blending mode of the top layer to Hard Light and using a large, soft Eraser tool (set to 50%) to remove random areas, I have blended parts of the normal picture with the blurred layer beneath. The Hard Light Blending mode has produced this Impressionistic result. The final Layers palette is shown in the screenshot.

Simulating movement

When we see a blurred object in a photo, we perceive it as having moved during the exposure, whereas a sharp object is perceived to be static in the scene. (Of course, a moving object can be made to look sharp by "freezing" it with a fast shutter speed.)

Generally, the more blurred an object is, the faster we assume it was moving. If only certain parts of an object are more

Aircraft in flight: original shot

This aircraft, performing a low, fast fly-by, was taken with a very fast shutter speed to freeze the movement. However, the result is a fairly static picture. I wanted to simulate the feeling of movement that would be created by panning a camera in the direction of the aircraft, causing the background to blur horizontally. First, I isolated the aircraft from the background using the selection tools, then I cut and pasted it to a new layer. The "hole" left by the aircraft in the background layer is filled in using the Clone tool.

Creating propeller blur

Because the fast shutter speed has frozen the propeller blades, I have erased them and created a blurred oval to simulate their rotation. This is done by making a new layer above the aircraft, drawing an oval with the Elliptical selection tool (to produce a perfect circle, hold the Shift key down), and then using a small brush and a dark colour to draw a straight line, which is subsequently blurred with the Radial Blur filter. This circle is made into a narrow ellipse using the Transform/Distort command, and positioned over the engine spinner. A duplicate (slightly smaller) has been made for the far engine. The area of the spinner has then been erased from the blur.

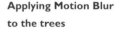

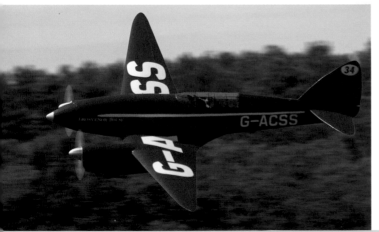

Applying Motion Blur to the trees

To create the panning effect, I have made the background layer active and applied the Motion Blur filter. To represent moderate speed, I have set the Angle to zero and the Distance to 45.

blurred than others, we assume that those parts were moving at a different speed.

If two objects are moving at the same speed in a scene, the one closest to the camera will record with more blur than the one further away. Also, a movement from side to side will cause more blurring than a movement towards or away from the camera. So, a car moving across the picture will blur more than a car travelling at the same speed towards the camera.

We can use our knowledge of how movement is perceived to simulate various forms of movement in our pictures. The main tools are the Blur filters, especially Motion Blur and Radial Blur.

Enhancing the speed effect

For a more dramatic effect, the apparent speed can be increased by making the background even more blurred. In this version I have used the Motion Blur filter with a Distance of 175. To make the aircraft look even faster, I've duplicated the aircraft layer and used the Motion Blur filter on the wings. This blurred layer is moved below the original plane and any blur in front of the aircraft deleted.

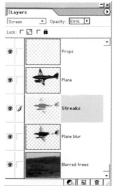

Converting to black and white

Black and white photography has always occupied a unique place in people's minds as the "artistic" side of photography, where prints are created in a darkroom by knowledgeable photographers. With digital imaging, it is now possible for everyone to produce black and white photographs without a darkroom.

You can either set your digital camera to record in black and white, or shoot your pictures in colour and convert them to black and white in your image manipulation software. I personally recommend the latter, because it gives you the greatest options.

There are several methods for converting a colour image into black and white. The simplest is to convert the colour file from RGB mode to Greyscale mode. This removes all colour information, replacing colours with shades of grey. It also reduces the file size to one third of its original size. Another option is to use the Desaturate or Remove Colour command. This leaves the image in RGB mode but removes all the colour information. Both these methods require no special input from the user and convert the colours to grey values automatically. This automatic conversion may not produce a particularly good black and white image. If your software has the facility, the most creative way to convert to black and white is to use the Channel Mixer command. This allows you to alter the tonal values of a picture to obtain different black and white images.

Once the colour image has been converted to greyscale, it may be necessary to use the Levels or Curves commands to adjust the tonal range of the image.

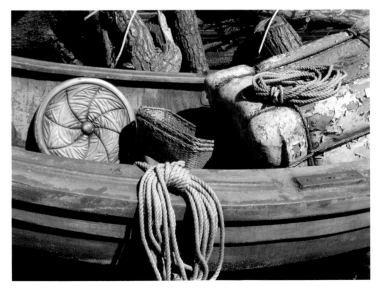

Boat rope:
original shot
The original picture has subtle, weathered colours, which when converted to black and white might look dull. When bright colours are converted to black and white, they produce brighter tones.

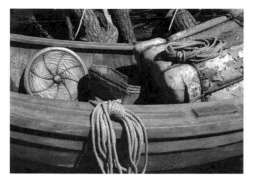 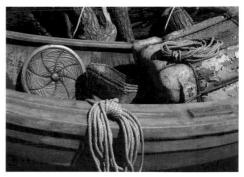

Greyscale mode

The easiest way to convert a colour picture to black and white is to change the RGB mode to Greyscale mode. The conversion will be automatic and produces a reasonable result, even with pastel colours, as demonstrated in this picture.

Desaturating colour

Another automatic conversion method is to use the Remove Colour or Desaturate command. This leaves the file in RGB mode and simply removes the colour information. As you can see, with this particular image the result is rather dull.

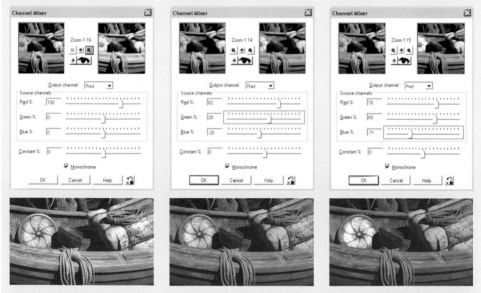

Channel Mixer

Some programs offer a Channel Mixer command that allows you to control how the colours are converted to tones of grey, enabling the production of different versions of the tonal values of a picture. This is similar to using black and white contrast filters in traditional film photography. As you can see from these examples, changing the proportions of Red, Green and Blue alters the tones of the picture. The dialog boxes show the values used in these examples.

Using film grain effects

Film grain is the pattern seen on enlargements of prints made from traditional film negatives. Since the advent of 35mm film, photographers have utilized film grain as a visual effect, either to create gritty-looking images, or to enhance romantic-style images such as female portraits.

Because digital cameras use an electronic device to capture an image, there is no grain. Therefore, to simulate the effect of film grain, it is necessary to apply the grain in your image manipulation software, using the Noise filter. Some programs, such as Photoshop Elements,

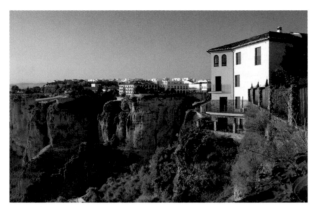

Rhonda, Andalucia: original shot

Film grain is easier to see in smooth areas of tone in pictures taken on a conventional camera. But in this picture, taken on a digital camera, there is no visible grain in the sky area.

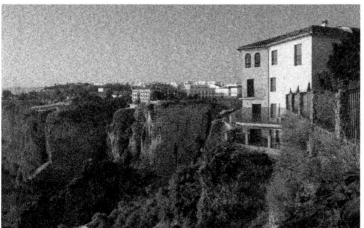

Noise filter

This shows the result of applying a Noise filter directly to the picture. To make the film grain obvious, I have used an Amount of 25%, as seen in the accompanying screenshot of the Noise filter dialog box. Note the reduction in contrast of the picture.

have a Film Grain filter under the Filter/Artistic menu, but this also produces colour distortions so I don't recommend it if you only want a film grain effect.

The Noise filter usually has options for controlling the size of the grain, the way the grain is distributed (film grain is never a regular pattern) and whether the grain has colour or is monochrome. The Monochromatic option is usually chosen for both colour and black and white pictures. The size of the grain is set with the Amount control and the Distribution is either Uniform or Gaussian (for a random grain use Gaussian). As with other techniques, using selections will restrict where the grain effect is applied in the picture.

Advanced film grain method

A method of applying film grain that leaves your original picture unharmed, is to create a new layer filled with 50% grey in Overlay mode. This can be done in one step using the New Layer dialog as shown by the screenshot here. The Noise filter is applied to this grey layer. The Amount value for this method needs to be higher than for the direct way – here I have used 300% (see the Filter dialog box screenshot). The advantage of this method is that the contrast of the original picture is retained. You can create different results by changing the Blending mode of the film grain layer, or applying other filter effects.

Lighting effects filter

This filter allows you to simulate the effect of different lighting conditions. It is useful when the original subject has been photographed in less than ideal lighting, or you wish to create special effects.

The Lighting Effects filter is from the Render filters group. It alters the colour and brightness values of individual pixels in the image. You can choose different Light Types – Spotlight, Directional or Omni.

Discarded bottle: original shot

I came upon this discarded bottle just a few minutes too late. The evening light was still on the bottle but almost off the rough background wood. I decided to recreate the lighting digitally, using a Spotlight in a warm colour.

Spotlight applied

This section of the main image shows the effect of the Spotlight without using the Texture Channel feature. Note the smooth surface of the label.

Texture applied

Here the Texture option has been used on the Red channel. Notice that the label now looks wrong and the text is badly affected.

The Spotlight is characterized by a circle of light that is lightest in the middle and fades to black at the edge. The amount of fade can be controlled by the settings in the dialog box. The Directional light simulates the parallel rays of the sun, producing broad areas of light. The Omni light is unique in that it throws light in every direction, producing an even spread of light – useful for creating pools of light. The texture in an image can be emphasized with the Texture Channel of the filter. This uses the grey values in a colour channel to simulate texture. Experiment with each channel to get the best effect. The amount of texture is controlled with a height slider.

Glowing bottle

For the final version of the image, two copies have been made and placed on new layers. The same filter has been applied to each layer, with one layer using the Texture Channel feature and one not. A layer mask has then been used to conceal the background on the untextured layer, so that the textured label from the layer below will not show. Some additional local darkening has been added by creating a new blank layer set to Multiply, and painting with the Brush tool at various Opacity settings.

Lighting Effects dialog box
This screenshot shows the Lighting Effects dialog box with one Spotlight on the image. Note the use of the Texture Channel.

Final image layers
Here we see the layers for the final image.

Complex digital lighting

By inserting various types of light in the Lighting Effects dialog box, and changing their colour and settings, all manner of complex effects can be created. You can control which areas of an image are affected by first using the selection

Canal and tree: original shot

This arrangement of bridge, tree and steps has been photographed in very overcast conditions, producing a rather boring effect. It is an ideal candidate for some digital magic!

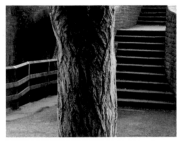

Edge-lit tree

I have made copies of the image on new layers, and then started by creating a selection of the edges of the tree trunk. The selections have been made softer as they move towards the centre of the trunk. This helps to produce the effect of a "fall-off" in light evident on a curved object. The rest of the image is untouched by the filter.

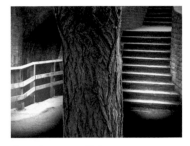

Creating streetlights

I am going to create the effect of two out-of-view streetlights. Using a different layer, I have applied the Lighting Effects filter, using two Spotlights to produce this result. The Spotlights have been adjusted individually to produce slightly different results on each side of the background. Notice how the filter has made large parts of the image flat, by reducing contrast.

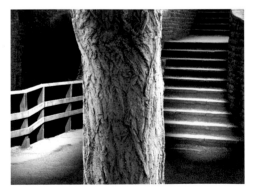

Adding shadows and form

Making the original image layer darker and bluer, adding a mask layer to the lighting layer and using the Polygonal Lasso tool has created shadows on the fence and stairs.

Nocturnal canal walk

The final image shows the dramatic results that can be achieved with just a few simple tools and plenty of attention to the desired effect.

tools to define the parts of the image you want to change.

Lighting filters can usually simulate texture by using a colour channel as a bump map, a greyscale image whose grey values are used to create texture. This should be used with care, because any smooth areas of the image will also be textured. Unfortunately, unlike real lighting, the filter cannot create object shadows in the image. This needs to be done by hand, as demonstrated here.

 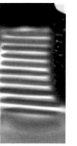

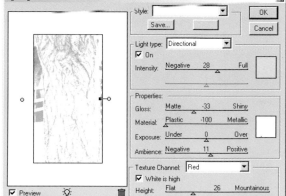

Layer mask

This shows the layer mask produced by creating shadows on different parts of the image. Note that various parts of the mask have different densities and softness. This gives complete control over how the layer blends with the layers below.

Tree lighting

The Lighting Effects box shows only the part of the image defined by the selections on the tree. Note the use of a Directional light on each side of the tree (see preview). Some mild texture has also been applied.

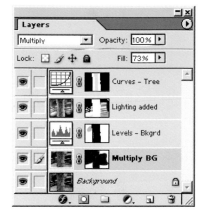

Background lights

For the background, two Spotlights are applied. The effect on the tree can be ignored, as this will later be removed by a layer mask.

Final image layers

This shows the final arrangement of layers used for the image. Note the use of layer masks to control different parts of the image.

Playing with perspective

Perspective is a natural visual effect that helps us to see the world in three dimensions and determine how far away things are – the further away, the smaller it appears. This size-to-distance relationship is mostly easily demonstrated when we look up at a tall building: perspective makes the top look smaller, and thus we know that it is high above us. However, when we look at a two-dimensional photo of a tall building shot from the same position, it may appear wrong because the sides of the building converge and we know that the sides are actually parallel. (*See also pages 26–27, Fixing Convergence.*)

The apparent perspective of a scene can be altered (and the picture of the tall building corrected) in image manipulation software using the Transform tools. These tools allow you to reshape all or parts of a picture; the most common are Skew, Distort and Perspective.

Matador: original shot
This picture is ideal for perspective manipulation because the background is fairly simple and already contains slight perspective, as seen in the sloping roof edge. The statue is also quite dramatic from this viewpoint.

Creating symmetry
To produce two perspective directions, known as vanishing points, I have created a corner effect by copying the background layer (dragging it to the New Layer button on the Layers palette). This new layer has then been flipped using the Rotate/Flip Horizontal command. The canvas has been doubled in width with the Resize/Canvas Size command. The two copies have been moved with the Move tool to create a composition with symmetrical corners.

Adding perspective

Each image half has then been reshaped using the Transform/Perspective command. The right half has received additional dramatic distortion with the use of the Distort command.

Adding lighting

I have used the Levels command on each layer of the picture to adjust the tonal and colour values, to simulate natural evening light coming from the right. This has helped to add realism to the scene.

Twin matadors

The final stage is to use the Clone tool to fill in the areas at the base of the picture and add a new sky. I have also changed the ground area around the base of the corner, so it is more in keeping with the lighting direction.

Creating a sunset

Sunsets are one of the most spectacular sights in Nature, and most people enjoy watching and photographing a good sunset. But the weather conditions that produce a sunset cannot be guaranteed to occur on the day you visit a beauty spot. One way round this is to use your image manipulation software.

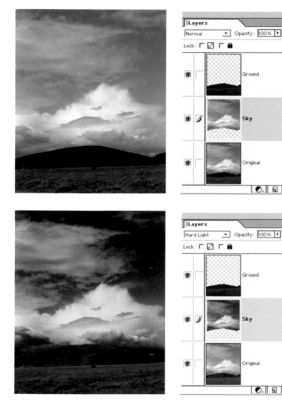

Landscape: original shot

To create a sunset effect, choose a picture with an interesting cloud formation. Also, it helps if the horizon line is easy to select, as in this landscape. Start by making a selection of the sky area and copy it to a new layer. Do the same for the ground area, by inverting the sky selection. The two main parts of the subject are now on different layers (see the Layers palette screenshot).

Creating the sunset

Making the sky layer active, use a Levels Adjustment layer to create the sunset colours. Select the Red Channel and then use the sliders below the histogram to control which of the sky tones receives the colour change (see accompanying screenshot). In this way, you can be very selective about how the colour is applied. Use the other colour channels to refine the result. Once you are happy, merge the sky layer and Levels Adjustment layer. Change the Blending mode of the new sky layer to Hard Light, so that the new colours interact with the original sky colours (see the Layers palette screenshot).

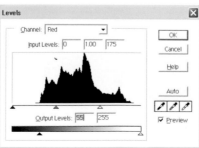

The software provides all the necessary tools for creating a sunset in a picture, whatever the weather or time of day in the original shot. By changing the colour, contrast and mood of a cloudy sky, you can create your own sunset. This can then be combined with a picture of a favourite scene to make a photomontage. As well as the tools built into the image software, there are also independent filter plug-ins that can create an infinite variety of skies, including sunsets.

Warming the ground

To make the land look like it is lit by a sunset, make a copy of the ground layer and use the same Levels Adjustment method to add warmth to the land. Place this layer above the ground layer, change the Blending mode to Colour Dodge, and reduce the Opacity to allow it to interact with the original colour of the land. Experiment to obtain a realistic result.

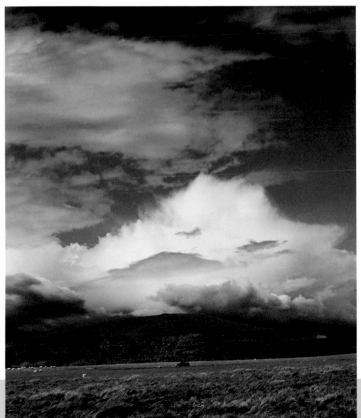

Final sunset

The final picture has received some local Brightness/Contrast adjustments to enhance the result. Don't worry about your skies looking dramatic – in nature anything is possible!

Digital frames

O ne of the great aspects of digital photography is the variety of ways that you can utilize your digital creations. To enhance the presentation of pictures when displaying them on the internet (for example in a personal gallery), via a mobile phone or in more traditional ways as prints, why not design a custom digital frame? This is a great way to "finish off" a favourite picture.

There are two ways to create frames digitally: either design your own using the

Draw the design

Create a new blank file of the required size. Either draw the design using the Drawing tools or import some clip art. For my art nouveau frame, I used one design for the top and bottom, and a simple scroll for the sides, with each part placed on its own layer for easy manipulation. Using the Move tool, I positioned each element, linked the layers and then merged them into one. For the oval part of the frame, I created a circular selection on a new layer below the main design and filled it with black. I used the Select/Modify/Contract command to make a smaller oval selection to delete the centre, leaving an oval ring.

Brushed metal look

(Before the next steps, ensure the Lock Transparent Pixels box is checked on each layer in the Layers palette.) To make a brushed metal effect, first use the Render/Clouds filter on each design layer to create random tones; then use Noise filter to generate random grain, and the Blur/Motion Blur filter, with an angle of 90°, to complete the effect. The Layers palette is shown for reference.

Creating a 3D effect

The 3D effect is created using Layer Styles/Bevel/Simple Inner. Apply this to the design and oval layers. To make the main design appear to be on top of the oval shape, I have created a drop shadow on a new layer (see Layers palette screenshot) between the design and oval layers, and then erased the parts outside the oval ring. Additional detail has been added using a narrow line around the design.

Drawing tools of the image software, or use a dedicated filter plug-in that will create frames for you. The latter method is obviously the easiest, but doing it all yourself allows you to be much more creative and to produce something that is genuinely unique.

For the DIY route, the first step is to get some inspiration from frame shops, architectural and art books, royalty-free clip art and stencil designs. Make sure that your design complements the picture you are framing rather than dominating it. Use the Pen, Pencil, Brush and selection tools to draw the design in the image program. If using clip art, import the design into your picture. Use any desired filter effects to make the frame look more realistic.

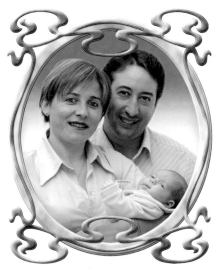

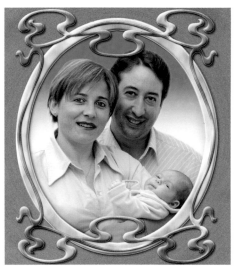

Add a photo

The next step is to place a photo in the frame. Use the Transform tools to size the photo, and then erase any parts that fall outside the frame (Control-click on the oval layer to make a perfect selection for this). I have used the Hue/Saturation command from the Enhance/Colour menu, with the Colourize option checked, to add colour to the frame parts. Colours have been chosen to harmonize with the colours in the photo.

Hanging the frame

The final step is to make the frame appear to be on a wall. I have created the wall by filling the background layer with colour and applying Noise, then Radial Blur. For added realism, I have added a drop shadow falling from the frame on to the wall and photo.

Using text on pictures

Text is applied to an image using the Type tool, and is automatically placed on a special Type layer. Using a Type layer means that the text can be edited at any time by changing attributes such as font family, style, size and colour. The font you choose determines the look of the text. Most fonts have styles such as regular, bold, italic and bold italic; also special styles such as underscore and strikethrough.

Prepare background

In this example, I am creating an imaginary CD cover for a collection of garage and house music. To represent the garage theme, I have chosen a black and white picture of old car tyres. To prepare this picture I have used the Image/Mode menu command to convert the file from Greyscale mode to RGB mode; to give the blue colour, I've applied a Hue/Saturation Adjustment layer with Colourize chosen.

Adding text

The next step is to add the text using the Type tool. I prefer to place each piece of text on a new Type layer so that it can be manipulated independently. (Size, colour and position the text using the Type toolbar.) I have then used the Create Warped Text command button on the Type toolbar to bend the text to follow the curve of the tyres. The settings used for the Warp Text command can be seen in the screenshots of the dialog box. The Layers screenshot shows the separate Type layers.

Text can also be manipulated with filters and other tools to produce fantastic results. However, before special effects can be applied to text, it is necessary to convert the Type layer into a normal image layer. This process is called rasterization, which means the changing of a file into the pixel-based image type required by Photoshop. In Photoshop Elements, use the Simplify Layer command under the Layer menu. Be aware that once you have done this, the text can no longer be edited.

Using text on pictures can be great fun – it allows you to create all sorts of items such as postcards, special occasion cards, leaflets, posters and so on.

Create text effects

I used Layer Styles to apply an Outer Glow and a Bevel to each Type layer. Using different settings for the Styles produces some variety between the main headings and the smaller text. The small "f" symbol on the Type layers in the Layers palette screenshot, indicates that a Layer Style is being used.

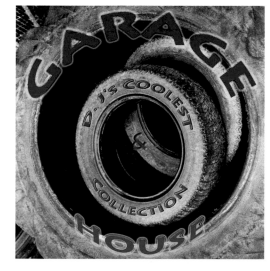

Garage CD cover

A new layer is added, with a circular gradient applied to darken the outer edges of the picture. This gradient layer uses the Multiply Blend and an Opacity of 40%. The Type layers have been converted to rasterized layers with the Simplify Layer command, so that the Noise filter can be used to "dirty up" the text.

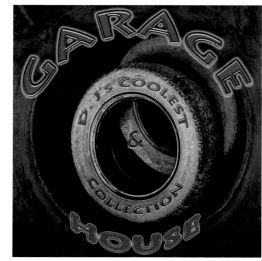

3

Making pictures work

The previous chapter has shown many ways of exploring your creativity by using different techniques to transform photos into something special. Once these masterpieces are finished, what then?

You may simply want to create a special, personalized greetings card for a loved one or friend. Alternatively, you may want to use the internet to display your favourite pictures to the world, creating a personal art gallery in cyberspace. Closer to home, you may want to create multimedia albums that can be played on the television – a great way to share exciting holiday moments with friends and family.

The following sections explore just some of the possibilities for making use of pictures in fun and exciting ways. With a little imagination, you should be able to devise many more things to do with your finished pictures.

Hard at work
Pictures are made to be seen, so don't just let your masterpieces sit in the computer – put them to work!

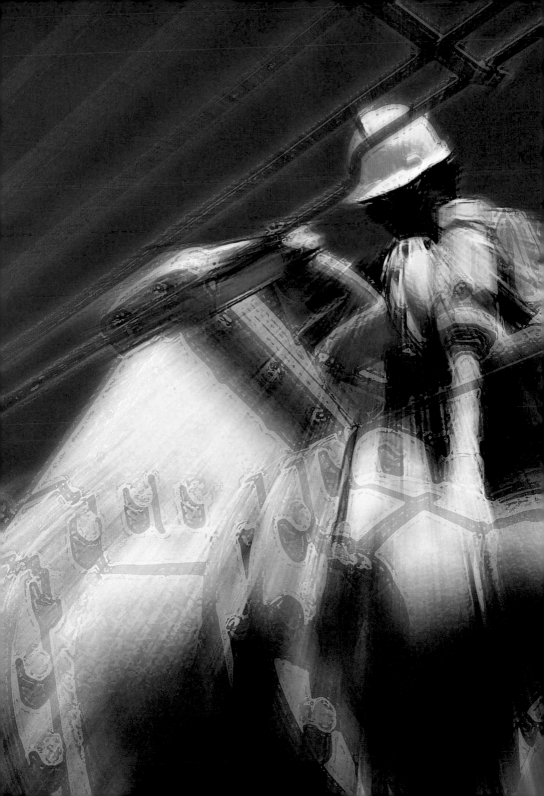

Making celebration cards

One of the most popular ways of using digital photos is to make personalized cards for birthdays, weddings, anniversaries, invitations and so on, where text and pictures are combined into one digital image. Plan the design and wording (and any special text effects you want to use) to suit the occasion. You may also

Create a border

Create a new file of the required size and format. (To simulate the use of coloured, textured card, fill the background with colour and apply the Clouds and Glass filters). Next, place your border design on a new layer. (I have used some clip art for the holly and Santa stocking, and created the lines using the Pencil tool.)

Place picture

Place the picture on a new layer and size it to fit the border. Make any necessary tone and colour adjustments.

Vignette picture

To create a vignette around the picture, use the Elliptical selection tool and draw the desired shape on the picture layer. Feather this selection to create a soft edge, invert the selection and press Delete to remove unwanted parts.

Add greeting

Use the Type tool to place the text on new layers (I prefer to put each word on its own layer to allow independent manipulation). Use the Rotate and Skew commands to tilt the text.

want to create ornate edges around the picture to further enhance the design. This can be done without too much effort, and can really make the card look really professional.

When the card is finished, it can be printed on specially prepared card that has a fold line embossed into it to permit easy folding. Check that your printer can accept the card you plan to use. (Photo-inkjet printers are only designed to take materials of a certain thickness, otherwise the print heads can be damaged, so refer to the printer handbook.)

Enhance the text

Finally, apply any other effects to the text. (I have used the Outer Glow and Drop Shadow Layer Styles to add interest and make the greeting stand out more. The Layers palette screenshot shows the final layer arrangement.)

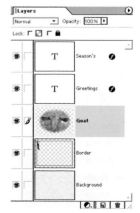

Making multimedia albums

The digital revolution has led to many new forms of entertainment and creative endeavour based around what has become known as multimedia, meaning simply the combination of pictures or graphics and sound. It is now easy for digital camera users to create their own multimedia productions in the form of digital albums. These can be shown to friends and family either on a computer or via a normal television.

Multimedia albums are a great way of organizing and displaying pictures with a soundtrack – perfect for special events such as holidays, birthday parties and weddings. They can also be used for creative projects such as a documentary-style record of your local area.

To make a presentation look more professional, titles and special effects can be created in your image manipulation program and saved ready to be imported into the album. When changing from one shot to another, transitions can be applied to make the change more interesting to the viewer.

Digital cameras often come supplied with a basic multimedia program to allow you to join pictures and sound together. Most computer operating systems, such as Microsoft Windows XP, also provide programs to enable you to make digital movies for use as multimedia projects. This software, and a selection of digital pictures, are all you need to start creating your own multimedia albums.

Gathering the elements
Microsoft Windows XP Movie Maker software is ideal for creating multimedia. (In this example, I am creating a brief instructional movie for use on a taekwondo website.) The first step is to import your media files into the container area, as shown here. You can import still pictures, video clips or sound files. These resources are known as clips.

Creating a storyboard

Once the clips are in the container, I have also added a title image, organize the clips by dragging each one to a frame on the storyboard at the bottom of the window. You can test the movie by running it; change the order of the clips until you are happy with the sequence.

Using the timeline

An alternative way of viewing the movie is with a timeline. This shows where each clip starts and ends, and allows you to control the timing of each one by moving it along the timeline. Here, I have added some sound files and dragged them on to the timeline. Now the sounds will start and end at the positions indicated on the timeline.

Using transitions

To complete the movie, I used transitions between the clips. A transition makes a movie easier to watch by blending one clip into another. In Windows Movie Maker, create a simple fade transition by using the timeline to drag a clip to the left so it overlaps the previous clip. The amount of overlap determines the speed of the fade from one picture to the other (see red circled area). In the preview window of the software, notice how the title image fades into the first clip.

Saving the movie

Once the movie is complete, you have the option of saving to the hard disk, to e-mail or to a web server for display on a web page. These options are to be found as File menu commands.

Sending email postcards

With the increasing accessibility of electronic mail, or e-mail, it is now very easy to share digital pictures with friends and family, no matter where they are in the world.

Before you send a picture file by e-mail, find out about the maximum file size your e-mail service provider will allow. In many cases, this is a maximum of one megabyte per e-mail. Digital picture files often have a

Making a postcard
Prepare the image by adding text and special effects to create a postcard. Here, I have made extensive use of the Layer Styles to generate an eye-popping title like those seen on holiday postcards. For the greeting, I have created a Type layer and then made a selection from this by Control/Command-clicking the layer. Using this selection, I have copied part of the picture to a new layer and then applied the Emboss Layer Style.

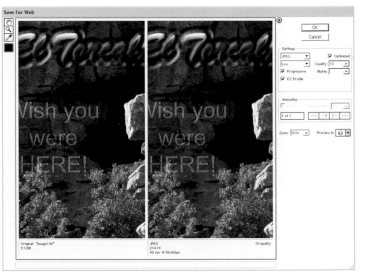

Picture optimization
To create an optimized picture file for sending by e-mail, use the Save For Web command on the File menu (Photoshop Elements). In the dialog box that appears, choose the options you need to obtain the best compromise between quality and file size.

Saving the picture
When you click the OK button, the Save Optimized As dialog box opens. Save the file as normal or as HTML. (Saving as a HTML file allows the picture to be opened directly in a web browser.)

size of many megabytes, so it is necessary to reduce the file size prior to sending. The problem with having to reduce a picture file size to under one megabyte is that it is then not usually large enough to be printed by the recipient. Therefore, e-mailed pictures are generally only viewable on a computer or television monitor. Note that the best resolution for monitor viewing is either 72 or 96 dpi (dots per inch), whereas for printing it is between 200–300 dpi.

Once a picture file has been sized and otherwise prepared for e-mail, simply add it to your e-mail as an attachment. If the files are small enough, you can send several attached to the same e-mail message.

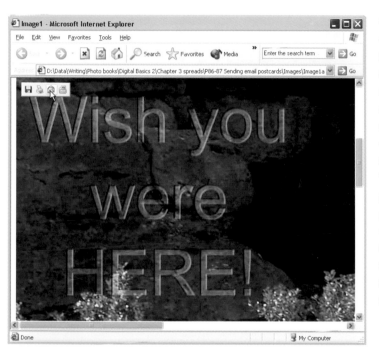

Creating the e-mail

Open the HTML file in your web browser to see the picture as it will appear on the internet. In MS Internet Explorer, right-click the picture or use the mini toolbar to choose the E-mail Picture command. This opens your e-mail program with the picture already set as an attachment. Simply choose the recipient for the e-mail, type in your message and hit the Send button to transmit the postcard.

Creating a web gallery

A web gallery is a website that contains a home page with thumbnail-sized images, and individual gallery pages with larger-sized images. Each page contains hyperlinks (these permit viewers to move around a document or website). When a

Web Photo Gallery

In Photoshop Elements, the Web Photo Gallery command automates the process of building a web gallery. The Options section of the dialog box allows you to customize the content and appearance of text and pictures for the web pages.

The Table display

This is the result of the choices made in the first dialog box. The Table style, selected from the Styles dropdown list, has produced a simple layout with each image in a cell. The command has also created links for each image, so that when someone viewing the gallery page clicks on a picture, a larger version opens on a new web page.

viewer clicks a thumbnail image on the home page, a gallery page opens.

In Adobe Photoshop Elements, the Web Photo Gallery command can be used to automatically generate a photo gallery from a set of images. The program also provides a variety of styles for the gallery.

Changing the display

By changing the Styles and Options in the dialog box, various different designs can be achieved. This dialog shows the Vertical Frame has been chosen. The dropdown Options list shows the various options that can be modified.

Vertical layout

Here we see the result of the choices made for our second example. This web design looks more sophisticated, but retains the easy-to-use approach. Links have been created so that when the viewer clicks on a picture in the lefthand column, a larger version is displayed in the righthand column.

Printing your pictures

Traditionally, the only way to obtain colour prints from a film has been to take it to a photo laboratory. This silver-based colour printing process is very complex and expensive to do. However, digital photography has revolutionized the printing process, and it is now becoming common for people with digital equipment to produce their own colour and black and white prints at home.

The main requirement for producing photo-prints is a photo-realistic printer. There are two main options to choose from: a dedicated direct printer, or an inkjet printer. The direct printer doesn't need a computer – you simply plug a compatible digital camera directly into it. However, you are usually limited to producing small-size prints. Also, the running costs of the media can be high.

Inkjet printers are by far the most versatile option for home printing, because they are available in a range of sizes to print almost any size of print. Some inkjet printers have a digital memory card reader built in, which means they can be connected directly to the camera. However, the most versatile inkjet printers connect to a computer and print from within the image manipulation program.

There is a vast range of different media available to print on – from smooth or textured paper to specially coated canvas. Some manufacturers sell sample packs, containing a range of papers, so you have the chance to try a variety of media at low cost.

A3 professional printer

This is an example of a professional-quality desktop inkjet printer. It is capable of producing large prints that can be used for exhibition.

A4 home printer

This Epson A4 inkjet printer is designed for the discerning home user to produce photo-realistic prints. This type of printer provides great quality for general photography.

Previewing a print

Before committing to print, use the Print Preview command on the File menu. The Print Preview dialog box allows you to make various decisions about how the image will be printed. Here you can choose where the image is placed on the paper, a colour for the paper, whether to add a black keyline around the image and whether to include a caption (this needs to be inserted using the File/File Info command).

Print command

With the Print dialog box open, you can decide on options such as the number of copies and print quality. (To get the most out of your printer, refer to its instructions for photo-realistic printing.) Click on the Setup button to open a dialog box that shows the options for the printer.

Printer options

Here are some of the specific options for this Epson printer. It is beyond the scope of this book to look at them all. The most important items to choose correctly are the type of paper and the paper size. Leave the colour management (Mode) on automatic until you know more about this option.

Contact sheets and multi-prints

Most image manipulation programs provide additional facilities such as making contact sheets, and printing the same image at various sizes on one sheet of paper.

A contact sheet is the traditional method used by photographers to catalogue their pictures. It is a collection of small images arranged in rows and columns on a single sheet of paper. Contact sheets provide a visual reference and are invaluable when you want to locate a particular picture. In Photoshop Elements, contact sheets can be created automatically using the Contact Sheets command found under the File/Automate menu.

Another useful technique is to print several different sizes of the same picture on a single sheet of paper. Photoshop Elements automates this task using the Picture Package command – found in the File/Automate menu.

Both techniques are easy to use and effective. When trying to locate an image, you'll find it is much easier to refer to contact sheets than to search through all the images on your computer.

Picture Package command

Use Choose in the Source Image area to select the picture. In the Document area, use the Layout dropdown list to select the size and quantity of prints from the pre-defined list. A preview of your selection will be displayed on the right of the dialog box. To print the images, set the Resolution at around 300 ppi (pixels per inch). If the image is only to be used on the internet, set the Resolution to 72 or 96 ppi.

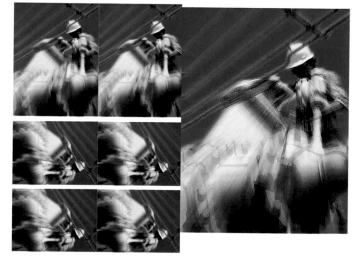

Multi-prints

The Picture Package command runs a macro that resizes the chosen picture and arranges the different sizes in a new file ready for printing.

Contact Sheet command

In the Contact Sheet dialog box, first select the Directory containing the picture files you are cataloguing. Next, go to the Document area and specify the Width, Height and Resolution. (To make contact sheets for printing, choose a size similar to the paper size, and set the Resolution to 300 ppi.) In the Thumbnails area, specify the number of Rows and Columns required (the more there are, the smaller the actual image.) Finally, choose whether to use the name of the file as a caption.

Contact Sheet II

Source Directory
Choose... D:\Data\Photography\Finished images\Colour\
☐ Include All Subdirectories

OK
Cancel

Document
Width: 21 cm
Height: 29 cm
Resolution: 300 pixels/inch
Mode: RGB Color

Thumbnails
Place: across first
Columns: 4 Width: 3.235 cm
Rows: 5 Height: 3.235 cm
☑ Use Filename As Caption
Font: Arial Font Size: 12 pt

Beach

Glen Coe

Mirror on wall

Olive trunks

Pier and pool

Rock 1 Castleri...

Hand and foot

Trees in crop f...

 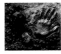

Water Lillies C...

Lamp Salford fi...

Maple

Antiquera 2

Boat

Olives

France #1

Rhino #1 Chester

Clouds with moo...

De Tapia

El Turcal 1

El Turcal with ...

Contact sheet document

Here we see the result of the options specified in the dialog box. The document can now be printed and filed, or you could add further information to it with the Type tool, such as the date, location and a reference number for the sheet.

Index

Acknowledgements

This is now my fourth book for Collins and Brown and I would like to express my heartfelt thanks to all the members of the team that make my books possible. Thanks must go directly to Emma Baxter and Jane Ellis for always being professional and a pleasure to work with. Thanks also to the designer, editor and print folk that make my ramblings and snaps look so good as a book.

Of course, no man is an island and working to deadlines inevitably has its impact on one's home life, so here's a big hug, kisses, and thanks to my partner, Barbara, for giving me a regular kick up the backside as encouragement to work.

Finally, many thanks to you, the reader, for buying this book and I hope you will get as much pleasure from using it as I did writing it.